IMAGES
of America

HOPEDALE

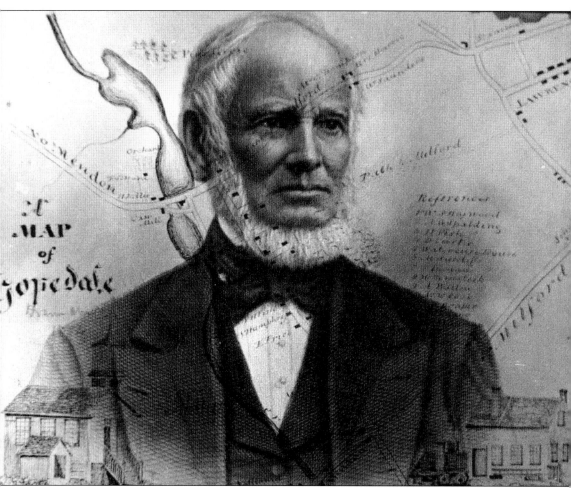

Rev. Adin Ballou, founder of Hopedale, was a social reformer. In the September 15, 1840 issue of his newspaper, the *Practical Christian,* he revealed his dream of establishing "a compact neighborhood or village of practical Christians, dwelling together in love and peace, insuring themselves the comforts of life by agricultural and mechanical industry, and directing the entire residue of their intellectual, moral, and physical resources to the Christianization and general welfare of the human race."

IMAGES
of America

HOPEDALE

Elaine Malloy, Daniel Malloy, and Alan J. Ryan

ARCADIA

First printed in 2002.
Reprinted in 2002, 2003.

Published by Arcadia Publishing,
an imprint of Tempus Publishing, Inc.
2A Cumberland Street
Charleston, SC 29401

Printed in Great Britain.

Library of Congress Catalog Card Number: 2002108572

For all general information contact Arcadia Publishing at:
Telephone 843-853-2070
Fax 843-853-0044
E-Mail sales@arcadiapublishing.com

For customer service and orders:
Toll-Free 1-888-313-2665

Visit us on the internet at http://www.arcadiapublishing.com

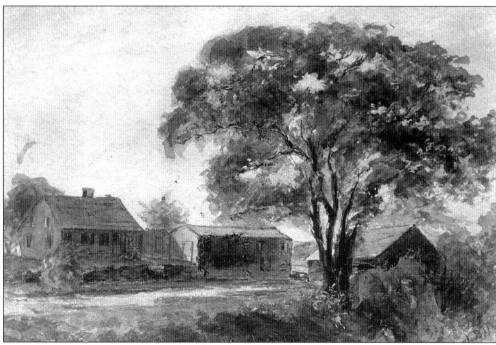

This early drawing depicts the Hopedale community's original dwelling (on the far left), and was dated 1852. The Old House, measuring 30 by 38 feet, housed the entire membership of the Practical Christians, which included 32 adults plus children. Adjacent to the home (in the middle) is a sawmill. To the far right are the stables.

CONTENTS

ACKNOWLEDGMENTS

At the risk of omitting some who have helped along the way, the authors would like to thank all those who contributed their photographs and wonderful personal stories. We feel the quality of this book has been greatly enhanced through the contributions of these individuals. They include Arnold Nealley, Arthur Allen, Robert "Zeke" Hammond, Dot Stanas, Roberta Simmons, Clayton "Buster" and Kathy Wright, Russ Dennett, Jean Guglielmi, Perry MacNevin, Myla Thayer, Thelma Shaw, Terry Studer, George Harlow, Francis Larkin, Edie Sanborn Bileau, David and Karen Warfield, Frederick Oldfield III, Glenis Bishop Hachey, Dave Clark, Frances Rae, Robert Morrissey, Donald Fafard, Michael Cogliandro, Janet Grant, Bill and Nancy Gannett, Edward Malloy, June Wright, Regina DelVecchio, Dick Grady, Doug Reynolds, Marge Horton, Bob Moore, Maya Fullum, Timothy Fullum, Charlie Felton, Lynn Barry Lutz, and Lena Bresciani.

We would also like to thank the Hopedale Historical Commission, the Bancroft Memorial Library, Morin's Studio, the American Textile History Museum (Claire Sheridan and Anne Cadrette), as well as our publishing team at Arcadia—particularly Jill Anderson—for their contributions to the book's completion. Our gratitude also extends to Kathy Kelly Broomer, the preservationist who compiled the Hopedale Village District National Register Nomination, whose thorough research provided invaluable information about Hopedale's architecture. We also respectfully acknowledge and thank the many deceased Hopedale residents who took the time to put their thoughts to paper in books, articles, and essays, such as *Hopedale Reminiscences* and *Hopedale as I Found It*, which provided much of the color for the book. Without them, and the town's forefathers, this wonderful community we call home would not be what it is today. Finally, we would like to thank our families for their patience and support during these months of meetings, research, and late nights to see this project from start to finish.

INTRODUCTION

Within two generations of the settlement of Plymouth, Massachusetts, the Nipmuc Indians sold 64 square miles of Blackstone Valley acreage to a group from Braintree and Weymouth. Settlers moved into the region, and in 1664, Benjamin Albee built a gristmill on the Mill River in what is now the south end of Hopedale. The area was incorporated as the town of Mendon in 1667. The mill and the rest of the buildings in Mendon were destroyed in 1675 during King Phillip's War, but Matthias Puffer erected a new mill on the site in 1684.

By the 1700s, more people were moving into the Mill River valley. Some were determined to form a new town from the Mill River area to the eastern extent of Mendon, and the result was the birth of Milford in 1780, including what is now Hopedale.

As the Industrial Revolution began in earnest, a gentleman by the name of Adin Ballou was turning his thoughts to making life better in ways that rivers and waterwheels could not. He was born in 1803 in Cumberland, Rhode Island, and in 1823 became the Universalist minister in Milford. By 1831, during an era of reform, Reverend Ballou had moved on to the Unitarian church in Mendon and soon became involved in the peace movement, women's rights, abolitionism, temperance, and Practical Christian Socialism. Ballou formed a network of reformers and, in 1840, began publishing a newspaper, the *Practical Christian*, to promote their ideas. He longed to establish a commune of like-minded individuals and soon had found a number of people interested in his plan. The group raised enough money to purchase a 258-acre farm on the Mill River. The area, known as the Dale, eventually became Hopedale. The buildings were in poor repair, but the group felt that the 24-foot drop in the river there would provide ample waterpower. In April 1842, Ballou and approximately 40 others with similar views moved into the Old House, which had been built in 1703. They quickly went to work planting crops, repairing buildings, constructing a shop, and building a structure that would serve as a chapel, school, dormitory, and office for the newspaper. Over the next several years, the community made progress in some areas, but its strict standards limited new membership. Moreover, it had difficulty establishing businesses that would generate enough income to support the group.

Still, by 1846, Hopedale had 70 residents, a dozen houses, a machine shop, a blacksmith shop, a sawmill, and two dams. Community members had also started producing temples, devices used in cloth-weaving looms to keep the cloth stretched to the desired width while it is woven. Following the cotton gin, the temple was the second American invention in the textile industry. By 1852, Ballou's community had grown to 200 members, the number of houses

had nearly tripled and its land doubled, more orchards and gardens had been planted, and several small businesses had been opened.

Through the 1840s and 1850s, Ballou and his followers continued to promote the causes with which they had been identified since the commune's establishment. They hosted antislavery meetings where Sojourner Truth, Frederick Douglass, and William Lloyd Garrison spoke to gatherings of more than 1,000 people. The community was also progressive in terms of women's issues. Women had the right to vote on community affairs, and many held committee memberships, though positions of leadership were rare. Abby Price, who had joined the settlement in 1842, delivered one of the major speeches at the women's rights convention in Worcester in 1850. Soon thereafter, Lucy Stone gave two lectures on women's rights in Hopedale.

While industry was at the forefront of 19th-century Hopedale, the community also established branches in agriculture and horticulture. During the 1850s, a large barn was constructed on the site of the present-day Dutcher Street fire station, and 25 acres were planted with corn and potatoes. Two thousand apple trees and a smaller number of other trees had also been planted.

Interestingly, most members of the Hopedale community were opposed to the idea of a communistic arrangement with all members owning an equal share. Rather, it was a joint-stock association with many members having few or no shares and a handful owning large numbers. Ebenezer Draper, in attempting to assist the community's growth, had used a large amount of the money he had earned in his temple business to purchase stock in the community. In 1853, he took his brother George into his business as a partner. George also became a member of the community but did not share all of the idealistic goals of Reverend Ballou and Ebenezer. In 1856, George convinced his brother to join him in withdrawing their investments, which amounted to three quarters of the total value of the community. This action resulted in the end of the Hopedale community, except for a few of its lesser functions, and the beginning of the Draper era.

The latter half of the 19th century was a time of tremendous growth for the companies along the Mill River in Hopedale. It was also a period of great personal success for the Draper family, which had acquired sufficient power and political influence to separate Hopedale from Milford and incorporate it as a town in 1886. By 1897, all of the businesses along the river were absorbed by the expanding Draper Company, and by 1900, it had become the largest producer of textile machinery in the United States.

For decades, the Draper loom-making business prospered; the Draper factory eventually consisted of more than 1.7 million square feet of industrial space and employed thousands. The Draper family members were benevolent owners, funding town buildings, unique duplex-style homes for workers, recreational facilities, and establishing open space known as the Hopedale Parklands. Yet as with others in the New England textile industry, the Draper Corporation found orders declining even before the Great Depression. Although the onset of World War II provided military contracts and kept business going for a while, foreign competition after the war resulted in a recurrence of the earlier problems. In 1967, North American Rockwell acquired a controlling interest in the Draper Corporation, and in 1980, the Hopedale plant was closed, marking the end of an era for Hopedale.

One

THE ADIN BALLOU YEARS

To understand Hopedale's early years is as simple as reading the street names in the historic village center: Peace, Hope, Social, Union, Freedom, Prospect, and Chapel. When joining the Hopedale community, founded by the Rev. Adin Ballou in 1841, prospective members were required to sign a "declaration" under which they agreed "never, under any pretext whatever, to kill, assault, beat, torture, rob, oppress, defraud, corrupt, slander, revile, injure, envy or hate any human being—even my worst enemy; never in any manner to take or administer any oath, never to manufacture, buy, sell, or use any intoxicating liquor as a beverage; never to serve in the army, navy, or militia of any nation, state, or chieftain; never to bring action at law, hold office, vote, join a legal posse, petition a legislature, or ask governmental interpositions in any case involving a final authorized resort to physical violence; never to indulge self-will, bigotry, love of pre-eminence, covetousness, deceit, profanity, idleness, or an unruly tongue; never to participate in lotteries, games of chance, betting, or pernicious amusements; never to aid, abet or approve others in anything sinful but through divine assistance always to recommend and promote with my entire influence the holiness and happiness of mankind."

Community members lived together at first in the Old House but over the years purchased more property and built homes and public structures to accommodate the community's growth. By 1856, the utopian experiment had failed, however, and the Drapers arose from its ashes to build an industrial-minded town.

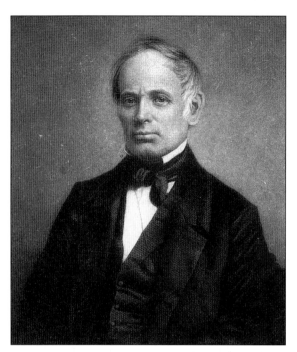

Rev. Adin Ballou was born in Cumberland, Rhode Island, in April 1803. He served as minister of the Universalist church in Milford and the Unitarian church in Mendon before moving to Hopedale. Firmly believing in the brotherhood of man, he and his followers moved into the Old House in April 1842, calling themselves Practical Christians. Their communal experience in the "Dale of Hope" was the longest lasting utopian experiment in Massachusetts.

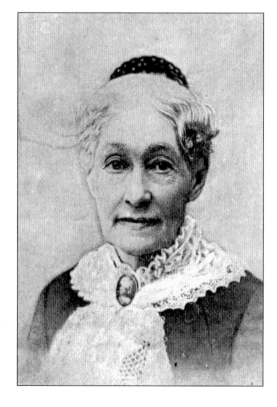

Lucy Hunt was born in Milford, Massachusetts, in 1810. In 1830, she became Adin Ballou's second wife; his cousin Rev. Hosea Ballou married the couple. Lucy and Adin had two sons together. Perley Hunt died at age two. Adin Augustus was born in 1833 and died of typhoid fever in 1852. Lucy also raised Abbie, a daughter from Ballou's first marriage. Lucy died in 1891.

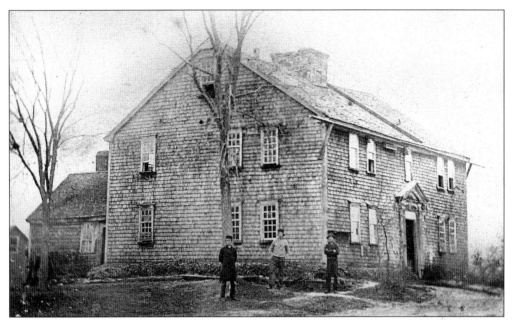

Sarah Daniels, in *Hopedale Reminiscences*, remembered the Old House, writing, "In 1841, the property was purchased as a site for the Hopedale Community. I was . . . two when my father, Henry Lillie and wife took up their abode [there], previous to the coming of the other members of the community. I remember the fragrant smell of herbs as the door opened. There were bunches of penny-royal, sage, catnip, and peppermint hanging with downward heads."

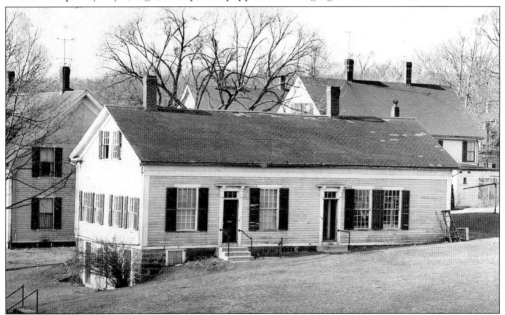

Frank J. Dutcher recalled in *Hopedale Reminiscences* that the community chapel was used for all gatherings, religious or secular, and school was held there on weekdays. Its basement was used as a community store. Near the street was a small bell tower equipped with a clock made by local artist Almond Thwing. The building, located on the corner of Hopedale and Freedom Streets, was razed in 1954.

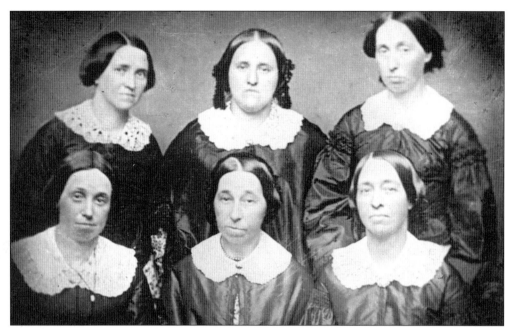

The six Thwing sisters were born to Benjamin and Anna Mowry Thwing and raised in Uxbridge, Massachusetts, but several later called Hopedale home. Seated, from left to right, are Susan (Anson), Sarah (Whipple), and Anna (who married Ebenezer Draper). Standing, from left to right, are Sylvia (who married Joseph Bancroft), Minerva (Knight), and Hannah (who married George Draper).

Abbie Ballou Heywood wrote of the Adin Ballou House in *Hopedale Reminiscences,* "My parents, much worn and weary with their experience in the Old House, decided to build a home of their own, to live 'under their own vine and fig tree,' and prosecute their labors for the good of mankind. They accordingly erected a cottage on Peace Street where now stands my father's monument. This was the third house in the village." In 1900, it was moved to 64 Dutcher Street.

Ebenezer Daggett Draper, son of Ira and Lydia Richards Draper, was born in Wayland, Massachusetts, in 1813. He married Anna M. Thwing of Uxbridge in 1834. They were attendants of Rev. Adin Ballou during his Mendon ministry and were members of the original community in Hopedale. They moved into the Old House in April 1842. The couple adopted several children.

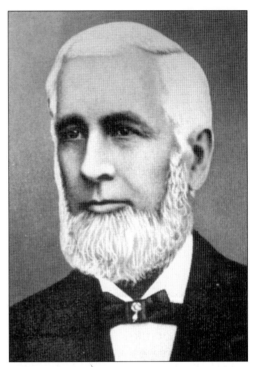

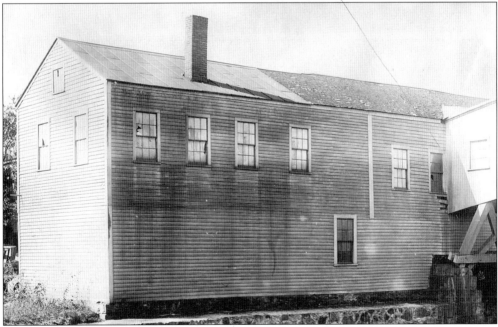

Ebenezer Draper purchased the family temple business in 1837 and moved to Uxbridge to be in the Blackstone Valley's mill district. When he joined the Hopedale settlement, he built the first Draper shop (today known as the Red Shop) on the site of the present plant. It is speculated that the building's cupola, not seen in this early view, may have been made for the community chapel and removed to the Red Shop when the chapel was converted into a home. The building's lower story is no longer part of the structure.

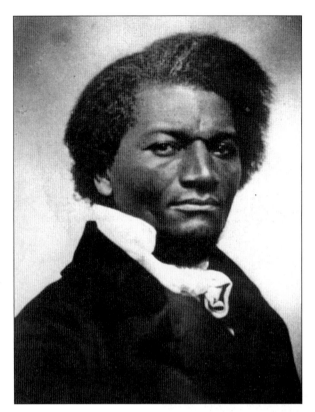

Adin Ballou noted, "Thursday April 7, 1842 was the annual State Fast Day. A public meeting convened. . . . The great pleasure was given us of entertaining for the first time Frederick Douglass [pictured] and of being more than entertained by his stirring words. He remained with us some days and did much during his stay to break into floating fragments much of the pro-slavery ice of Milford and vicinity. Memorable times these!"

Joseph Burbier Bancroft was born in Uxbridge, Massachusetts, in 1821. He married Sylvia Thwing in 1846. They came to Hopedale and joined the Hopedale community the following year. Bancroft was a machinist and eventually became superintendent of the Hopedale Machine Company. Later, he rose to be vice president and then president of the Draper Company. He died in 1909. (Photograph courtesy the American Textile History Museum, Lowell, Massachusetts.)

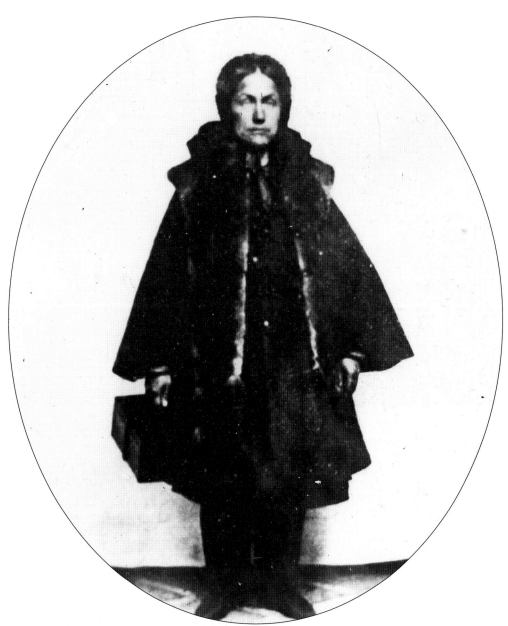

In the early community, there was a general attitude of progressiveness. Emily Gay (pictured) served as doctor, a position she had earned by studying medical texts and working with other physicians. In *Hopedale Reminiscences,* Imogene Mascroft remembered Dr. Gay, saying she was "a familiar figure on the street, dressed in her bloomer costume, whose only justification was its convenience, carrying her little medicine chest, hurrying along with her swinging arms and gait, doubtless reaching her patient's side in good time, even if a runabout had not been heard of." Ida D. Smith recalled in *Hopedale Reminiscences,* "At one time 25 women, all clad in bloomers, went to Worcester to attend a women's rights convention. They attracted so much attention that the police were called to protect them!" In the later 1850s, Phila Wilmarth, widow of the doctor who had operated a water-cure clinic on Hopedale (then Main) Street, became the second woman to practice medicine in town.

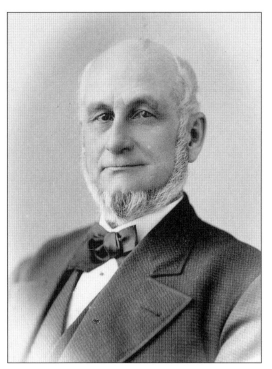

George Draper, born in Weston, Massachusetts, in 1817, married Hannah Thwing in 1839. They moved to Hopedale in 1853, and he joined his brother in the firm of E.D. and George Draper. In 1854, he purchased an interest in the Dutcher temple, and a partnership, W.W. Dutcher and Company, was formed with the inventor. Other industries headed by the Draper brothers included the Hopedale Machine Shop and the Hopedale Furnace Company.

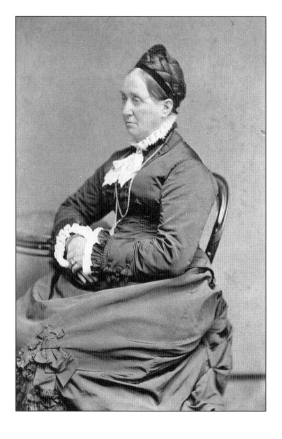

Hannah Brown Thwing was born in Uxbridge, Massachusetts, in 1817 and married George Draper in 1839. The couple had eight children, but two died in infancy and one was stillborn. Those who survived were William Franklin, Frances Eudora, Hannah Thwing, George Albert, and Eben Sumner.

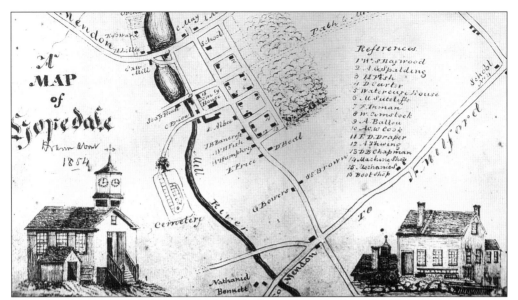

On December 26, 1851, the *New York Daily Tribune* reported on the Hopedale community, saying, "Their present domain . . . contains about 500 acres. Their village consists of about 30 new dwelling-houses, three mechanic shops, with waterpower, carpentering and other machinery, a small chapel, used also for education, and the old domicile with barns and out-buildings much improved. There are now 36 families making in all a population of about 175 souls."

In 1845, the Practical Christians laid out a burial ground, although little work was done on it until the typhoid epidemic of 1847. "The only road to the cemetery was a rough cart path through a succession of pastures, and in case of a funeral it was necessary to pass through several pairs of bars," recalled resident Frank Dutcher in *Hopedale Reminiscences*. Today, this is known as the Hopedale Village Cemetery. (Photograph courtesy the American Textile History Museum, Lowell, Massachusetts.)

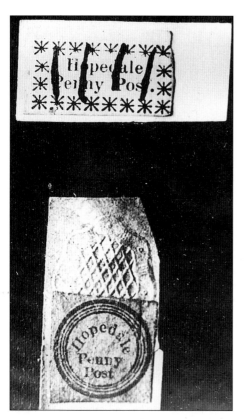

When the community began, Hopedale's mail was brought from the Milford post office by anyone who happened to go there. A community post office was established in Hopedale *c.* 1853. To pay for the work of carrying the mail, a stamp was issued which cost the sender or receiver $1\frac{1}{2}$¢, according to Susan Thwing Whitney in *Hopedale Reminiscences*.

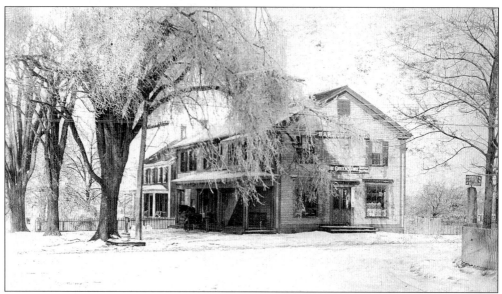

In 1910, John Albee recalled, "Over the Green Store is Harmony Hall where Adin Ballou preached his gospels of Universalism, temperance, peace and abolition on Sunday afternoon following the morning services in his parish. As my family was attached to the Baptist and Methodist persuasion, I cannot now imagine what drew them to hear this famous reformer, but any kind of meeting was a temptation not to be resisted in that little community."

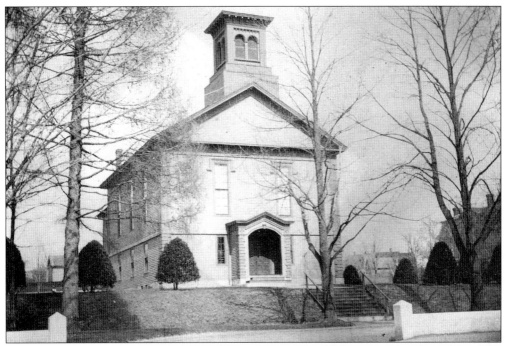

The Hopedale Parish (today the Hopedale Unitarian Parish) began in October 1867. Adin Ballou served as the first minister for $800 a year. The original church, built in 1860 for $6,000, was 58 feet long and 44 feet wide and could seat 500 people. The first floor held the Sunday school, a ladies parlor, and a kitchen. The second floor was devoted to religious services and concerts. The church, the interior of which is shown below, was razed in 1897.

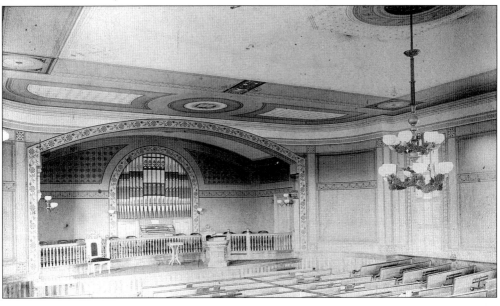

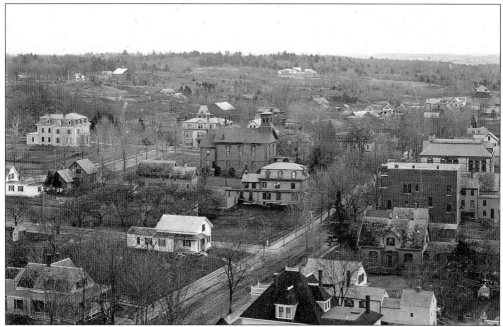

Early life in the Hopedale village revolved around its center along Hopedale Street. Roads were unpaved, and water wagons (as seen above) helped control the dust. The bungalow (in the middle of the photograph) belonged to Almond Thwing, abolitionist. *Hopedale Reminiscences* states that a former slave named John was hidden there. Joseph Bancroft, prominent citizen and benefactor of the Bancroft Memorial Library, owned the large house in the foreground.

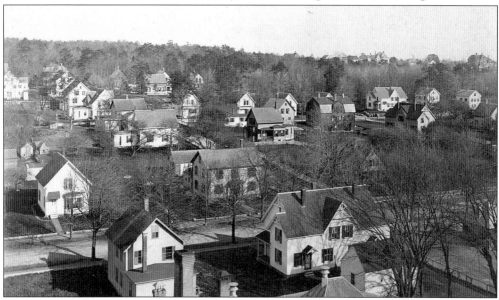

Many in the early Hopedale community believed in a medical treatment that involved a series of "sweats" followed by very cold baths. In 1849, an infirmary known as the Water Cure House (in the center of the photograph) was established for such treatments at the corner of Hopedale and Union Streets. Ironically, Dr. Wilmarth, who ran the operation, later died by drowning. The building has been replaced by a modern duplex.

Two

THE DRAPER YEARS

Ebenezer and George Draper withdrew their shares in the Hopedale utopian experiment in 1856 and concentrated on building their loom-making business. By 1900, the Draper Corporation was renowned as the world's largest manufacturer of automatic cotton looms.

The Draper complex featured a variety of buildings, including a foundry and the "pattern safe" building, a fireproof structure where the loom parts patterns were stored when not in use. The factory also contained a massive steam plant with underground piping used to heat not only the plant but other public buildings, including the town hall, the Bancroft Memorial Library, the Little Red Shop, and the fire station.

The Draper brothers left their mark on Hopedale between the public buildings and mill housing they erected, their own family estates, the beautiful pond they created by damming the Mill River, and the serene Parklands surrounding the Hopedale Pond. In their wake was the legacy of a benevolent corporation that continued to thrive through successive generations of Draper family descendants. Over time, the Drapers built the Hopedale Airport and contributed to the construction of the Hopedale Country Club.

During the period of Draper prosperity, other shops made their mark on Hopedale as well, including the Roper Mill on Northrop Street, and the Spindleville Mill on Mill Street.

After several decades of leadership and providing for thousands of workers, the Draper Corporation faced increasingly stiff competition from foreign loom manufacturers, and by 1967, the plant was sold to Rockwell International. Its doors were closed forever in 1980.

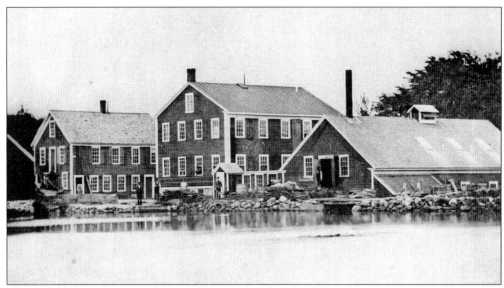

This early view of the Draper operations shows (on the far left) the hardening shop where temple teeth were made. The building to its right housed the office of Ebenezer and George Draper, a tin shop, and a shoe salesroom. Third from the left is a woodworking shop erected by community members in 1842, and to its right is the original foundry built in 1856.

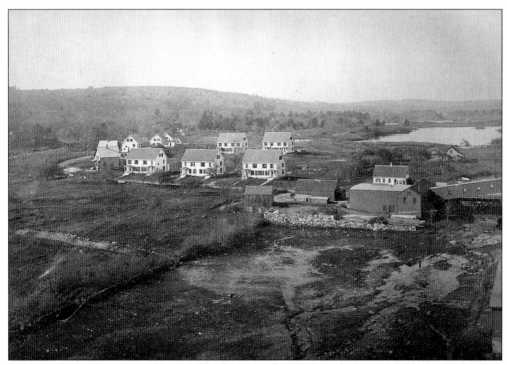

Construction of the current Draper plant began in the 1880s and continued for several decades. This photograph was probably taken from the tower and shows an early stage of groundwork. Housing along the bend of Freedom Street is seen in the background.

Warren W. Dutcher was living in North Bennington, Vermont, in 1854 when George Draper bought an interest in his improved temple. In 1856, Dutcher and his business moved to Hopedale, where they formed a partnership with George and Ebenezer Draper known as W.W. Dutcher and Company. (Photograph courtesy the American Textile History Museum, Lowell, Massachusetts.)

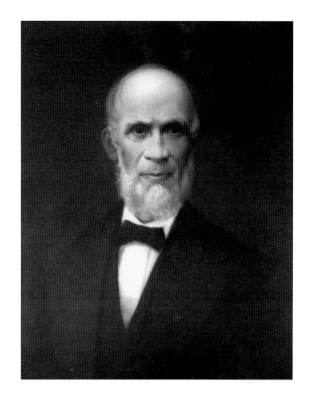

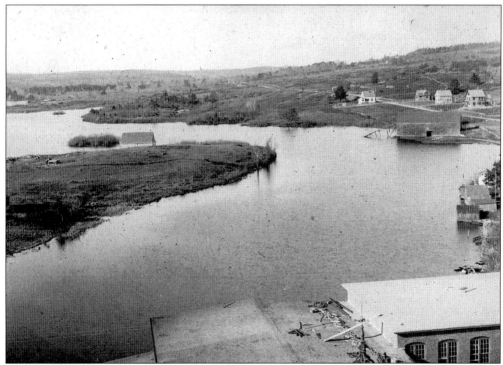

This photograph of the Draper plant and Hopedale Pond was taken prior to the development of the Lake Street area.

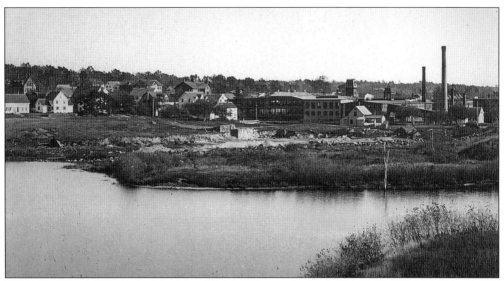

Entitled "Corner of Hopedale, Massachusetts," this early view was taken from the Lake Street area. Barely visible near the left horizon is a boardinghouse known as the Park House. Also seen over the rooftops is the Chapel Street School.

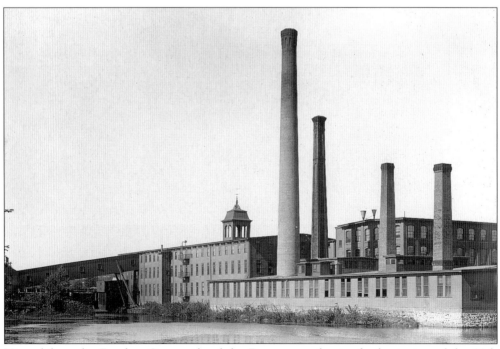

Viewed from the Freedom Street side of the Draper complex in the beginning of the 20th century, the typical Industrial Revolution sights of chimneys and a bell tower provide a glimpse of Hopedale's largest employer's operations.

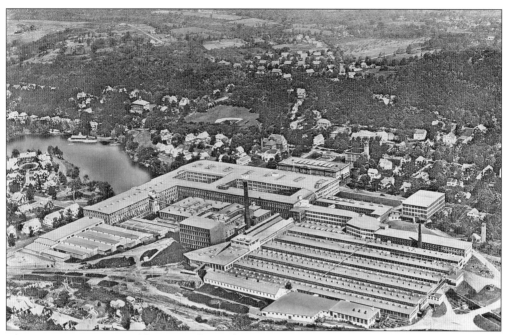

The Draper Company sold 285,000 looms between 1899 and 1914. Its workers also produced ring-spinning devices, shuttles, and other textile equipment. The company had its own foundry where it manufactured the metal parts for the looms. The molds for the parts were stored when not in use in a fireproof building known as the Pattern Safe Building.

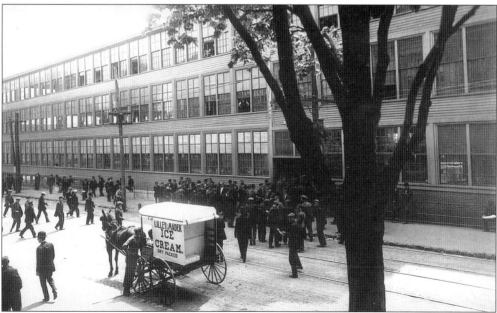

Working for the Drapers or other factories meant long days. "In the period of which I write [1910], we worked until six o'clock in the evening for five days a week, and until noon on Saturdays. We didn't seem to mind it, having known nothing else in other places. In fact, this was more free time than I had before, when I had to work on Saturday afternoon," recalled Charles F. Merrill.

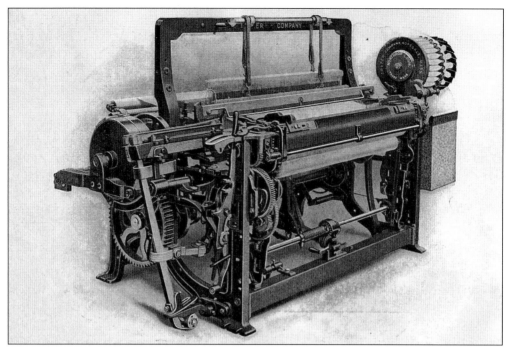

In 1886, the Draper Company began an enormously expensive eight-year program to develop an automatic loom. Many new inventions and improvements were needed to achieve this goal. James Northrop's idea for pushing the used bobbin out of the shuttle and replacing it with a new one was a major step. After many other problems were solved, the first shipment of an order of 792 Northrop looms was delivered in 1894.

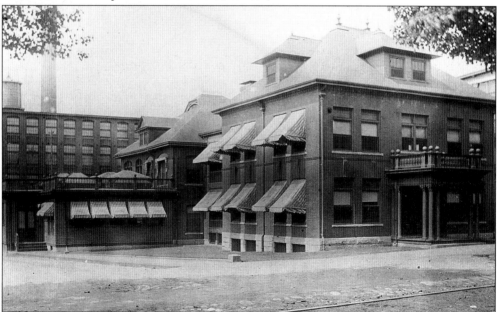

The Draper office, seen here, was located on the west side of Hopedale Street. It was eventually replaced with a newer one on the eastern side of the street. This building was razed, and the main manufacturing plant was built on the site.

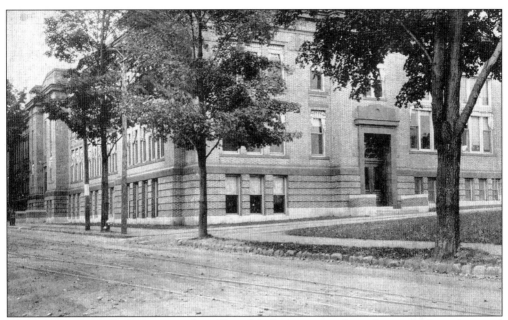

The Draper main office was situated on Hopedale Street, across from the main plant. A tunnel connected the two buildings. Individual offices were located on two levels around the outer perimeter. Resident Dot Stanas recalled, "Movies for children were shown on the back wall of the building on the Fourth of July." After being vacant for many years and falling into disrepair, it was eventually sold and developed into an assisted living facility, Draper Place.

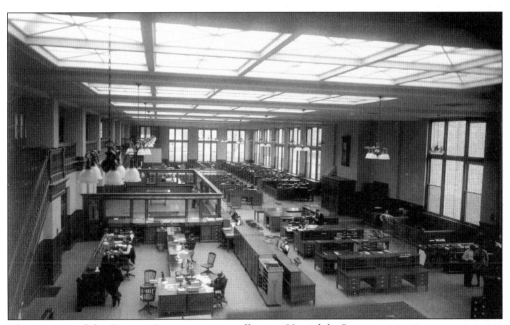

The interior of the Draper Company main office on Hopedale Street was an important center of activity. Individual offices with beautiful oak finishes were located on the building's perimeter. Ornate gas lighting fixtures added a touch of charm. (Photograph courtesy the American Textile History Museum, Lowell, Massachusetts.)

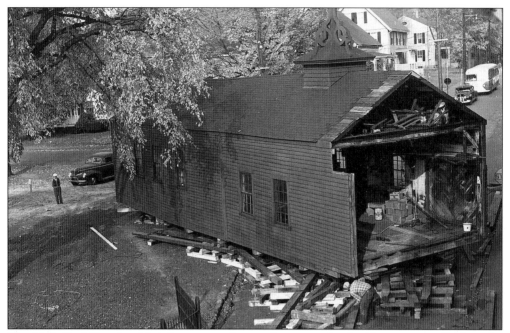

The Little Red Shop has likely been moved more than any other building in town. Built as the original Draper shop on the east side of the Mill River, on the present plant site, it was first transferred to the opposite shore. Later, it was moved to the corner of Lake and Freedom Streets. In the 1950s, it was transported in sections to its fourth and current location on Hopedale Street.

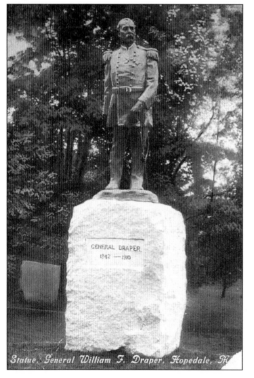

This statue of Gen. William F. Draper once stood on the grounds of his estate, the site now occupied by the high school. What became of this monument remains an intriguing mystery, although many believe it was buried on the property.

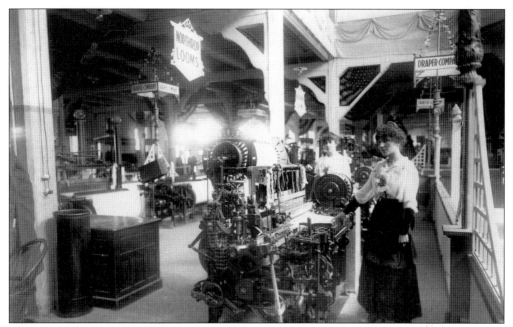

The upper photograph, taken at a textile show in 1916, showcases the important role that women played for the Draper Company in public settings. Note the prominence of the Draper name on display, as well as that of the loom (Northrop) that made the company famous. The lower photograph shows a Draper Company trade show exhibit on display in June 1914, possibly in Mechanics' Hall in Worcester. (Photographs courtesy the American Textile History Museum, Lowell, Massachusetts.)

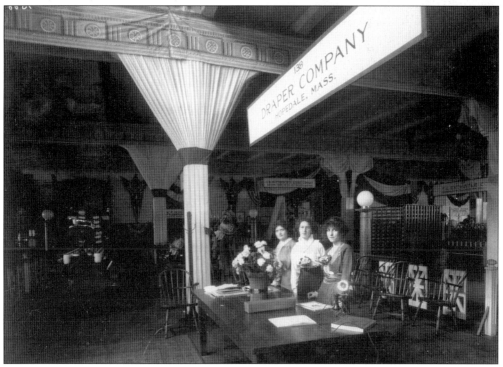

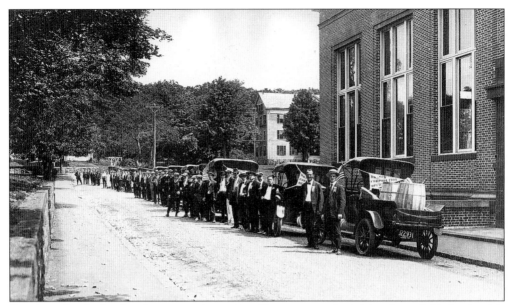

People and vehicles lined up near the main office to open festivities for a field day in this photograph, which was probably taken in the 1920s.

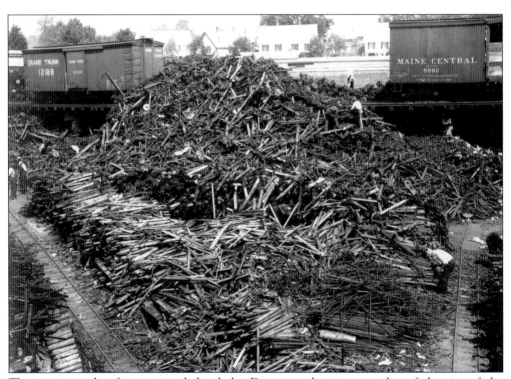

This massive pile of scrap iron behind the Draper works gives an idea of the size of the company's operation. One can estimate the enormity of the mound by comparing it to the size of the workers and railroad cars. (Photograph courtesy the American Textile History Museum, Lowell, Massachusetts.)

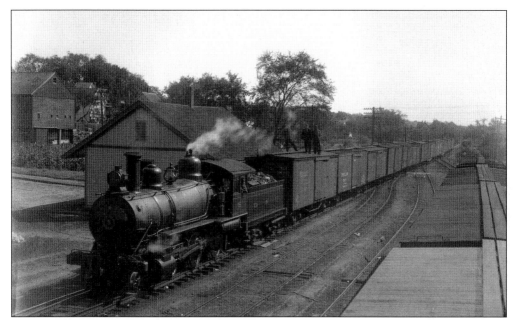

The Grafton and Upton Railroad provided freight service for the Draper business from the 1890s to 1967. Prior to its acquisition by Draper, the railroad line included a freight yard next to the plant, a spur line into the plant, a station (c. 1889), and a turntable at the end of the spur line. This photograph shows a train used for transporting looms. (Photograph courtesy the American Textile History Museum, Lowell, Massachusetts.)

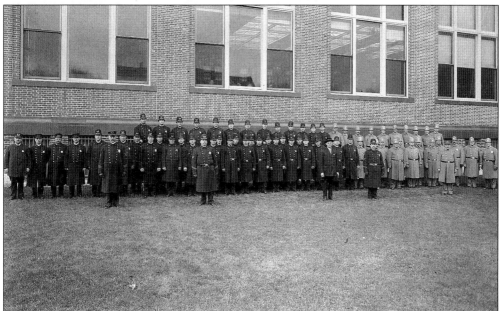

In 1912, area socialists invited leaders of the Industrial Workers of the World (IWW) in Lawrence to unionize Draper Company workers. IWW's interest in Draper may have been the result of Gov. Eben Draper's veto of an eight-hour workday bill. The strike began on April 1, 1913, with more than 1,000 workers participating. The plant remained open, however, and police were brought in from Boston, Worcester, Lowell, and Lawrence to prevent any disturbances.

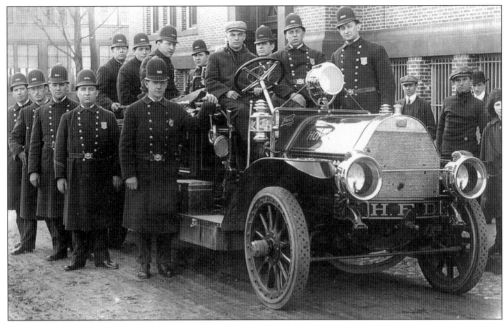

On April 24, 1913, after an episode of stone throwing at workers by the strikers and shooting at the police, the police fired back. The strikers ran to a wooded path leading to Milford. Soon after, Emilio Bacchiocchi was found dead, having been shot in the back of the neck. The company continued to function, and by July, the strike ended in a defeat for the IWW and the strikers. (Photograph courtesy the American Textile History Museum, Lowell, Massachusetts.)

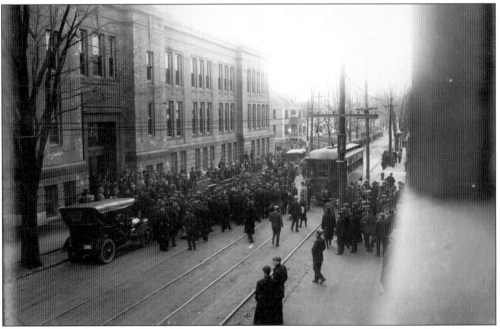

This view shows strikers on Hopedale Street in front of the main office in 1913, with the trolley and cars nearby. (Photograph courtesy the American Textile History Museum, Lowell, Massachusetts.)

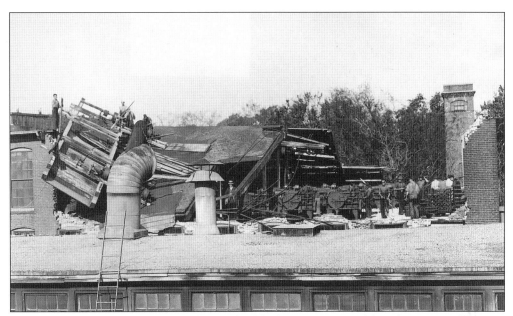

A September 1938 hurricane caused considerable damage in Hopedale. This picture illustrates the storm's effect on the roof of the Draper plant and shows workers beginning the overwhelming task of cleanup.

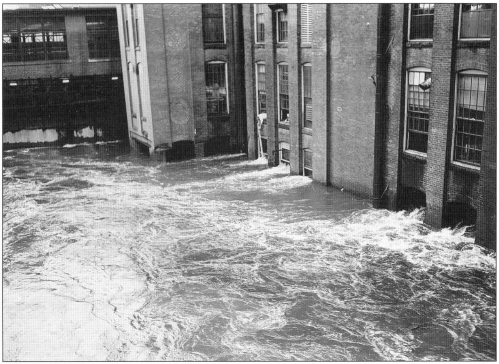

In the summer of 1955, a flood occurred in the region. This photograph shows Hopedale Pond floodwaters gushing into the Draper plant through windows on the Freedom Street side. Workers can be seen in two windows—the one on the left appears to be trying to measure the depth of the water.

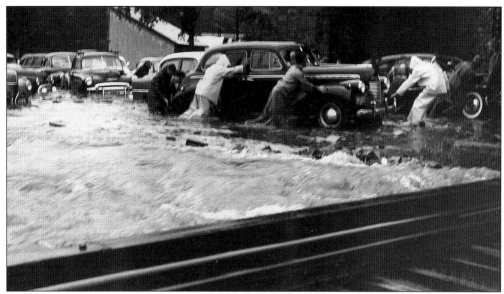

Draper Corporation employees try valiantly to save their cars from the floodwaters in 1955.

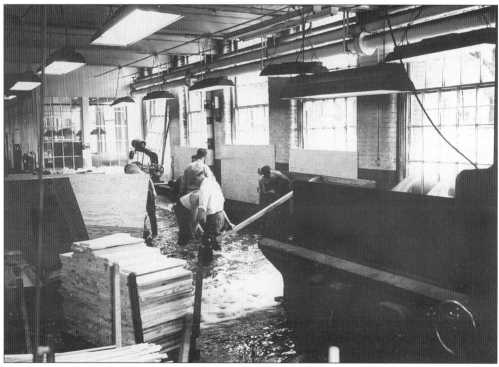

Workers inside the Draper plant deal with the aftermath of the 1955 flood.

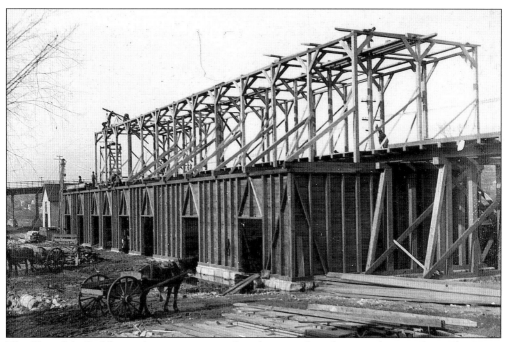

The Hopedale Stable was being constructed at the time this photograph was taken. The Hope Street Bridge is seen in the background, along with horse-and-wagon teams in the foreground.

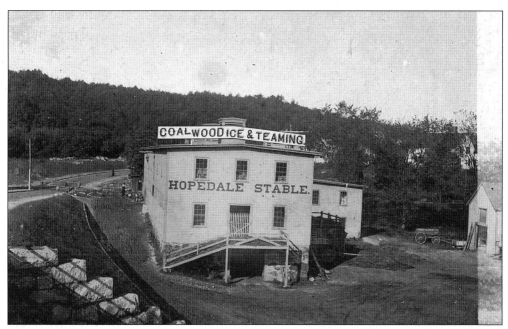

The Hopedale Stable was located at the western end of the Hope Street Bridge, as evidenced by the stone abutment. Signage on the roof, "Coal Wood Ice & Teaming," likely dates this photograph to the late 1800s.

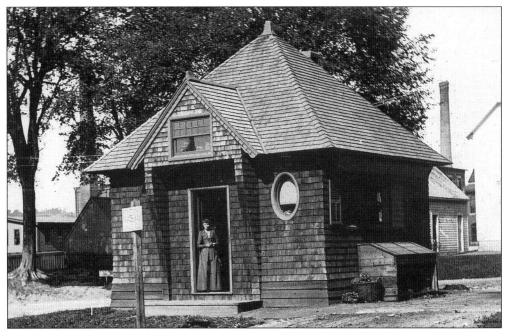

These images showcase the Hopedale Coal and Ice office in the 1890s. Note the woman at the door in period dress in the photograph above. In the picture below, the proprietor's entrepreneurial spirit is shown in the signs reading, "Coal Wood Hay & Ice," and near the door, "Light and Heat, Teaming, Furniture and Piano Moving a Specialty."

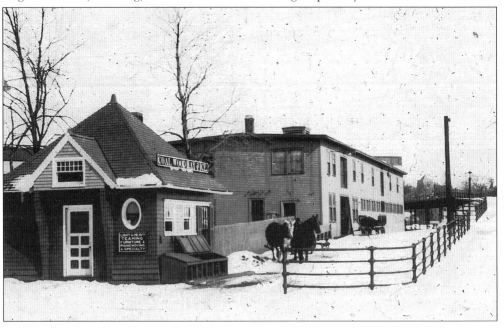

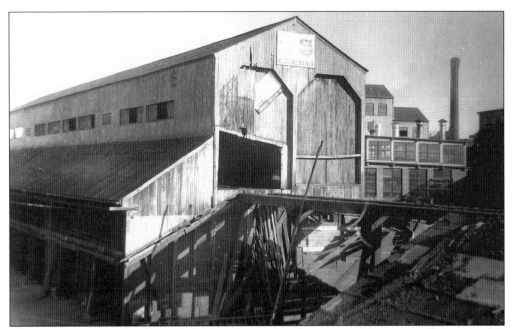

This is the coal trestle at the Hopedale Coal and Ice building, off Fitzgerald Drive. Railroad hopper cars would go into the building and drop their coal. Coal was still burned in many Hopedale homes into the 1950s.

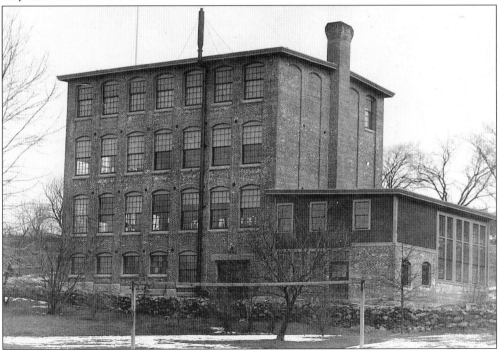

Clare Draper, son of William F. Draper, joined Charles F. Roper to form C.F. Roper and Company. The company manufactured Roper's safety propellers, envelope sealers, gasoline gauges, and automobile and boat accessories. The factory pictured here produced pumps, and was located on Northrop Street, adjacent to the Town Park. Today, a brick home occupies that site.

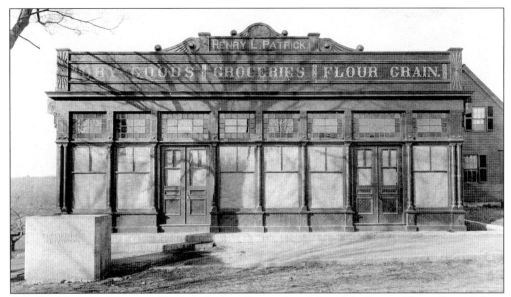

After building the Harrison Block (which still exists) on Hopedale Street, Henry Patrick later built this wooden structure, into which he moved his business, next door. The grocery and dry goods store was between the Harrison Block and the library, on the present site of the medical building parking lot. These views were taken in 1888. Note the ornate stained-glass windows just below the roofline and the finely crafted woodwork inside the store. (Photographs courtesy the American Textile History Museum, Lowell, Massachusetts.)

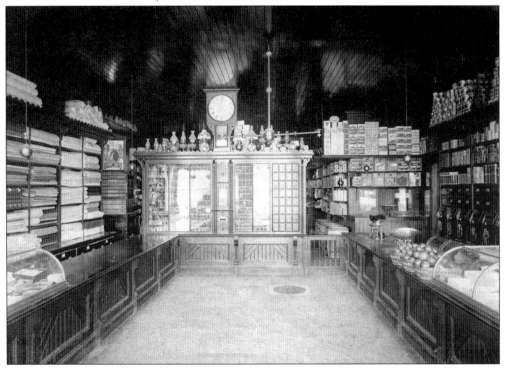

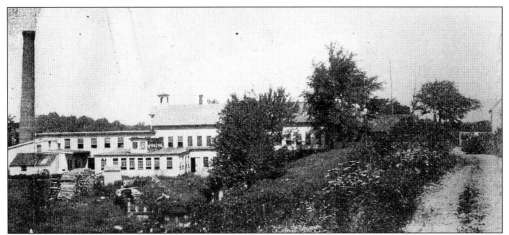

On September 13, 1947, the *Woonsocket Call* reported on the Spindleville mill as follows: "The shop, according to Asa Westcott, was originally a cider and gristmill, but was converted to a spindle shop about 76 years ago by his grandfather. The original shop was destroyed by fire in 1901 but was rebuilt by the next year. The trip hammers went through the fire but were salvaged and are still in daily use."

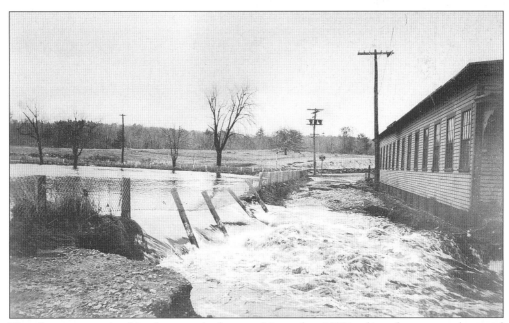

The damage seen in this photograph dates to November 1927, when there was substantial flooding in Hopedale. The view focuses on the devastation around the A.A. Westcott Mill at Spindleville Pond.

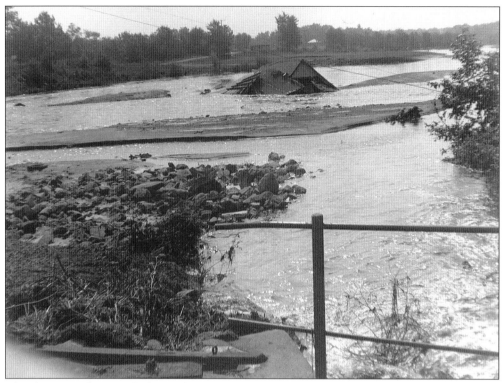

This dramatic photograph shows the very real devastation of the 1955 flood. In this scene, the Hatt home and store, located at the corner of Green and Mill Streets, was swept away in the floodwaters. Part of the Westcott Mill was destroyed during the same flood.

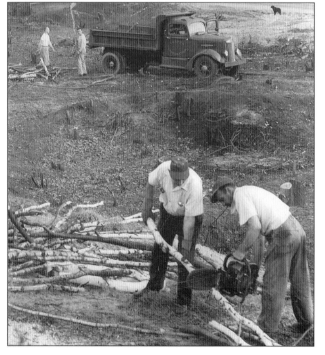

This later photograph shows the construction of the Hopedale Country Club's first fairway in the 1950s. In the foreground are Earl Simmons Sr. (left) and Earl Simmons Jr. The fairway they helped construct became the fourth fairway in 1995.

Three
A MODEL
COMPANY TOWN

Providing housing for the families of factory workers was of such importance in the years the Draper homes were being built that competitions were held and medals awarded for superior designs at world fairs. The Drapers took this quite seriously and erected unique, spacious, and practical housing for their workers, believing that duplexes were superior to multifamily apartments because each resident would have his own front door and yard. Gold medals were awarded for Draper housing at the St. Louis Exposition in 1904, Liege in 1905, and Milan in 1906, and a silver medal was received at the Paris Exposition of 1900. By 1916, the Draper Company owned approximately 500 homes. Tenants took pride in the town, keeping the streets and yards tidy.

When constructed, many of these sturdy double homes featured Tudor styling and Victorian touches and had wooden-shake roofs, cedar-shake siding, and architectural accents, such as ornate brickwork chimneys, stained-glass windows, and uniquely patterned window shutters. The interiors had hardwood floors, and many offered built-in amenities, such as bookcases and china cabinets. The architects hired by the Drapers were generous with space, and many of the homes had three or more bedrooms on each side, with additional basement and attic space for storage. Streets were laid out to provide, whenever possible, views of Hopedale Pond. By 1910, all of the worker homes had electricity, water and gas lines, and indoor plumbing.

Double house tenants enjoyed low rents, and to help maintain the structures, each year they were entitled to have a room painted or wallpapered at their discretion.

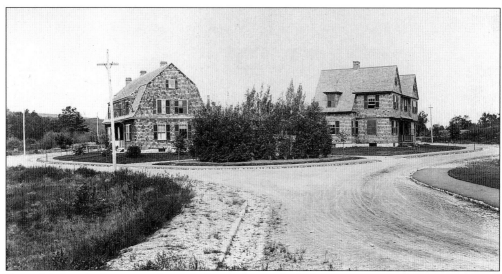

Beautiful though they were, the early Draper homes lacked some amenities. Charles F. Merrill recalled from *c.* 1910, "Our house in Bancroft Park would now be considered rather primitive. There were no laundry facilities, and the washing had to be done in the kitchen with tubs. . . . There was no gas or electricity, and our light came from kerosene lamps. The ironing was done with . . . irons heated on the stove."

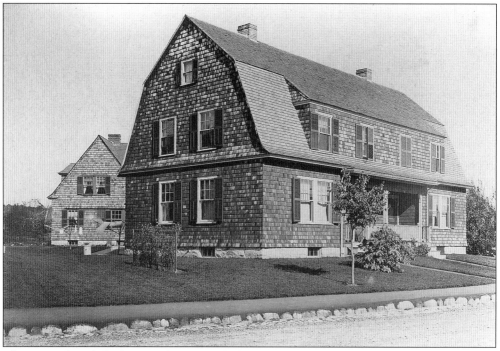

The Bancroft Park duplexes, and many of the later ones built for Draper shop workers, were clad with unstained cypress shingles. Interior finish work was done with North Carolina pine, and the floors were of maple or beech. The plumbing included an iron kitchen sink, an enameled tub and lavatory, a vitreous (water) closet, all connected by brass water pipes.

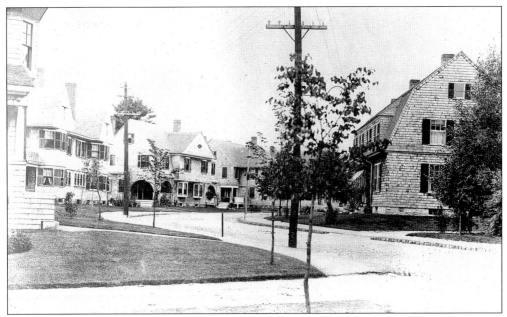

The Draper family strove to provide comfortable, affordable housing for its employees. The first area developed was Bancroft Park in the 1880s. Striking designs won international awards. Conveniently located, strategically positioned, beautiful streets, and low rents made these homes extremely popular. As the Drapers continued to expand into other areas of town, Hopedale workers were among the first in the region to enjoy homes with electricity and indoor plumbing.

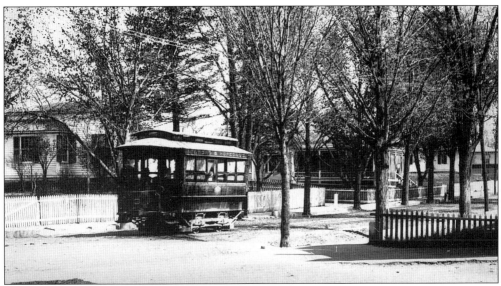

On an early spring day, people boarded the trolley on Hopedale Street near Peace Street. A small child peers out a window, perhaps eager for adventure. Directly behind the trolley is Adin Ballou's house. This is now the site of Adin Ballou Park. Next to it is Ebenezer D. Draper's house. To the far right, barely visible, is the Osgood house situated on what is now the Hopedale Community House lawn.

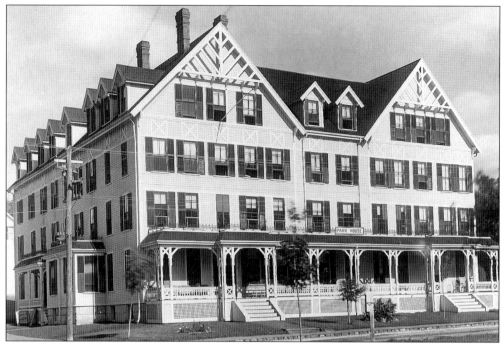

The Park House was a stately and picturesque boardinghouse for Draper employees. The Tudor structure, built in 1887, was situated at the intersection of Freedom and Dutcher Streets, facing the Dutcher Street School. The building was eventually razed. Today, a modern duplex occupies the site.

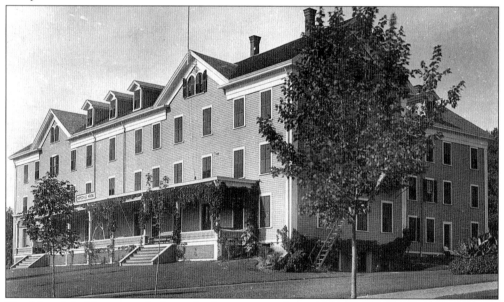

The Hopedale House was built in the last quarter of the 19th century. Located on Dutcher Street, it was the largest of the Draper boardinghouses. Originally it had a porch extending across most of the façade. In an 1899 remodeling project, a long center hallway with a reception parlor and dining space was added to the first floor. Note that in this view most of the shutters are closed.

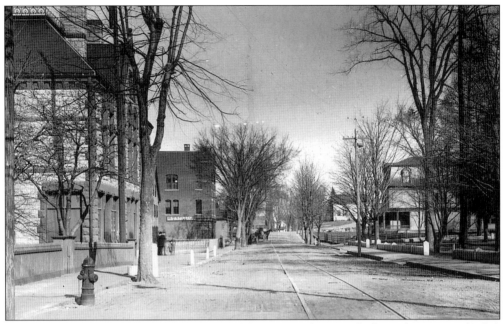

This early-1900s view looks north on Hopedale Street. The town hall can be seen in the left foreground. Beyond that is the Harrison Block. The mansion on the right is the Osgood house. Trolley tracks can also be seen. Hopedale's first town leaders felt that signs, including those that named streets, resulted in an untidy appearance. It is rare to see any in early photographs.

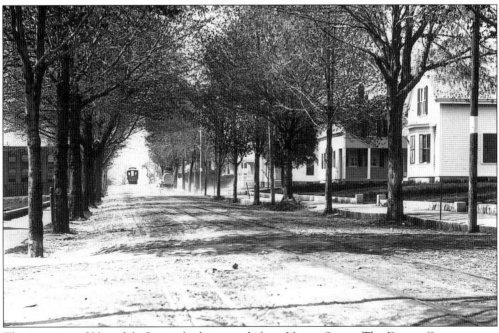

This is a view of Hopedale Street, looking north from Union Street. The Draper Company can be seen on the left, as well as the trolley, a familiar sight of the time.

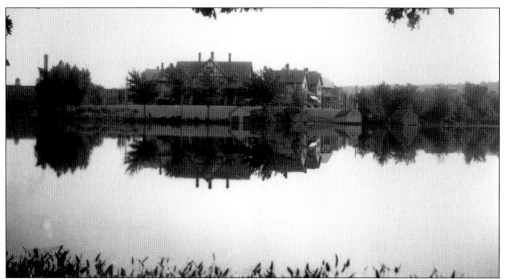

Arthur Shurcliff, landscape architect, had specific reasons for his design of the Lake Point development. He felt the old-fashioned way of positioning homes with their backs to the millpond and an interior road had problems. Rubbish, ash dumps, clotheslines, and privies could be seen and would be unattractive and unhealthy, he said. Houses built facing the water with a road in front of them, however, would fend off the unsightliness and protect the shore. (Photograph courtesy the American Textile History Museum, Lowell, Massachusetts.)

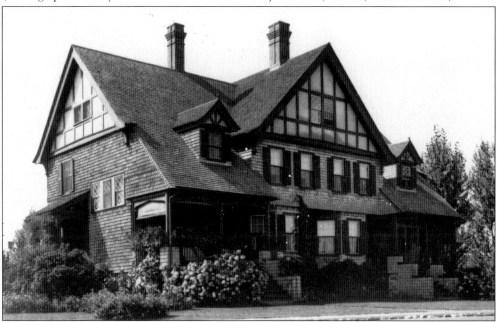

A village improvement society was started in 1886, and by the 1890s, the Draper Company was awarding cash prizes for well-kept yards. A neat appearance, such as in this Lake Street property, continued to be important to the company as suggested by a statement in the *Cotton Chats* newspaper in 1912, which stated that "shrubs and flowers are not allowed to offset a slackly kept lawn or untidy back yard." (Photograph courtesy the American Textile History Museum, Lowell, Massachusetts.)

46

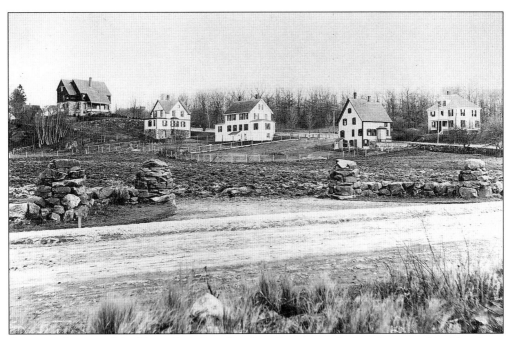

A very early view of the Town Park from Dutcher Street reveals that the ground had just been cleared. The Roper house is visible at the top of Freedom Street.

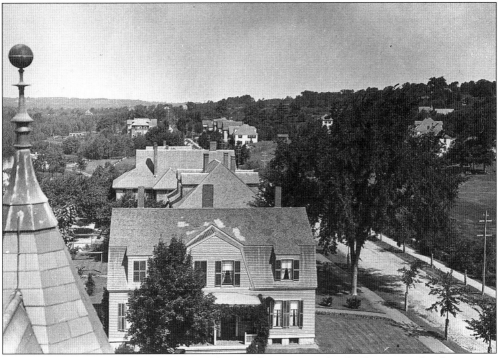

This *c.* 1900 view looks north from atop the Dutcher Street School. The Draper family, aspiring for a gardenlike appearance throughout the town, planted 300 American elms along Dutcher Street and hundreds of maples along other streets in town. The Town Park, seen on the right, provided the setting for field days and band concerts. It remains a focal point for leisure activities.

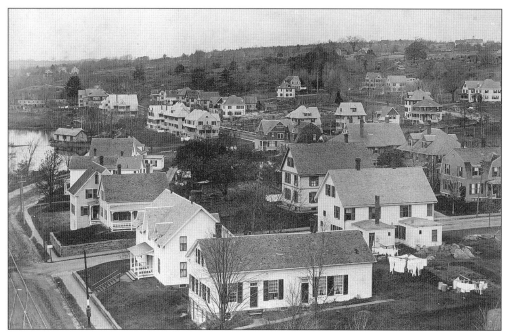

"I knew nothing of Hopedale before 1910 when I arrived in the early evening in April of that year, stepping off the trolley car that had brought me from Framingham in an hour and a quarter for the price of 15 cents. I found myself in a neat, quiet, well-ordered village, whose inhabitants were, apparently, comfortably prosperous, and the air had a country freshness that was delightful." —Charles F. Merrill, resident.

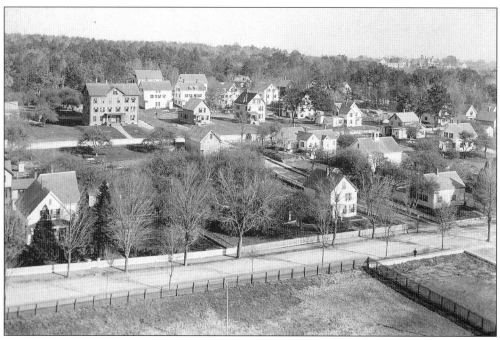

Taken from atop the Draper plant, this bird's-eye view features Hopedale and Dutcher Streets in 1893. In the 1890s, Hopedale offered 12 miles of paved streets and 2 miles of sidewalks.

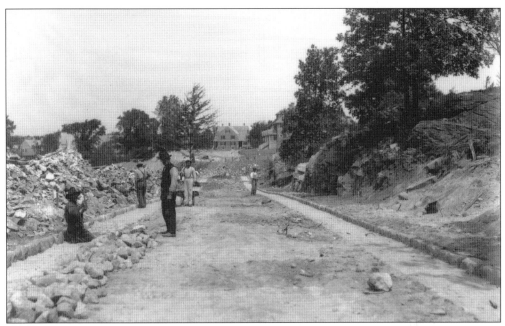

Taken on June 6, 1914, this photograph of Inman Street being constructed shows workers grading the road. (Photograph courtesy the American Textile History Museum, Lowell, Massachusetts.)

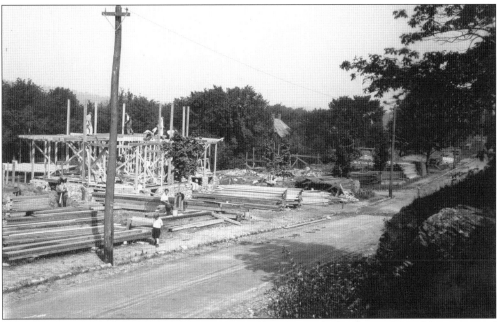

This 1920 photograph, taken on Inman Street, illustrates a duplex being framed by a group of carpenters. Lumber laid out in the background shows that a neighborhood is being created. The small child on the unpaved street appears to have lost interest in the project. (Photograph courtesy the American Textile History Museum, Lowell, Massachusetts.)

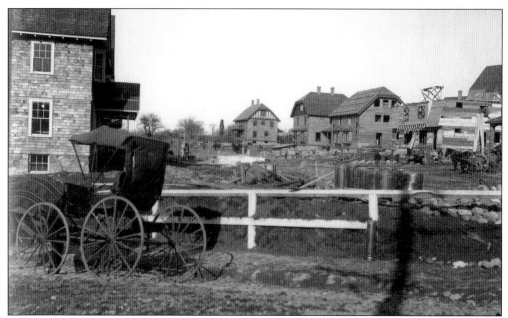

This view, from the corner of Northrop Street and Jones Road, was taken on December 12, 1913, and shows housing in various stages of construction, with workers, horses, wagons, and unpaved roads providing a feel for what life was like in the early part of the 20th century. (Photograph courtesy the American Textile History Museum, Lowell, Massachusetts.)

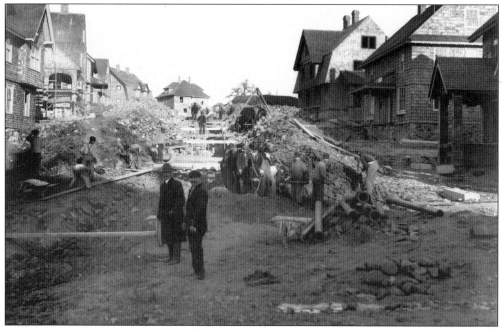

A memory captured on December 12, 1913, reveals the immense efforts taken to create the Hopedale duplexes. The view looks up Oak Street from Northrop Street. Workers appear tiny in comparison to the tremendous piles of dirt and stone. (Photograph courtesy the American Textile History Museum, Lowell, Massachusetts.)

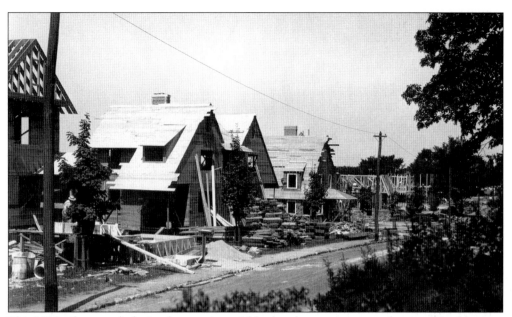

This 1920s photograph depicts how entire neighborhoods were constructed at once. In this view, homes are under construction on the west side of Inman Street, beginning several houses south of Elm Street. (Photograph courtesy the American Textile History Museum, Lowell, Massachusetts.)

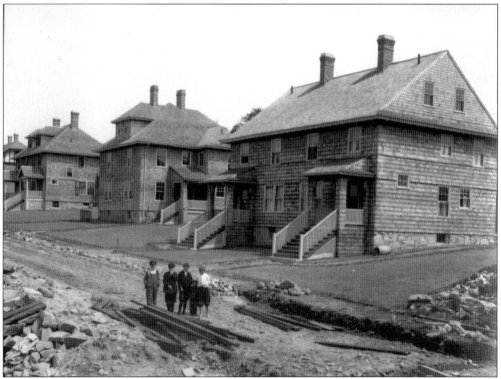

Construction continues on an unpaved Inman Street while inquisitive children look on in this photograph taken on June 6, 1914. (Photograph courtesy the American Textile History Museum, Lowell, Massachusetts.)

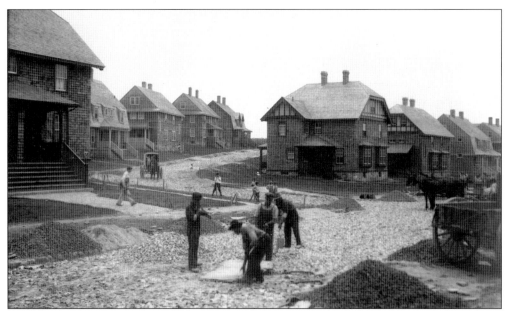

This photograph, called "new tenements," featuring Maple Street and Jones Road, was taken on July 9, 1914. Workers are immersed in the task of grading a street. Horses and wagons illustrate how materials were hauled to and from the work site. (Photograph courtesy the American Textile History Museum, Lowell, Massachusetts.)

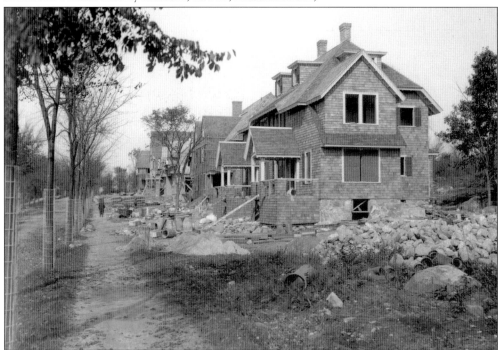

This early view of Dutcher Street was taken on October 23, 1913, and shows unfinished homes with stone foundations. Young trees are still supported by protective caging, and a lone individual walks down the unpaved street. The view looks north, beginning with No. 165. (Photograph courtesy the American Textile History Museum, Lowell, Massachusetts.)

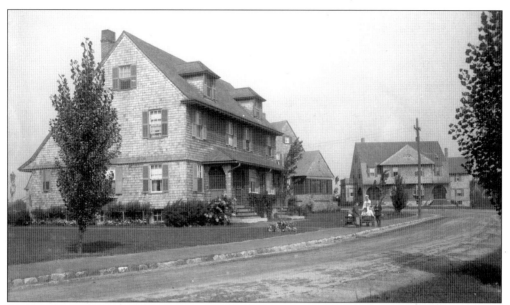

This photograph, entitled "Tenements-Lake Street," was taken on September 11, 1913. These homes were some of the finest examples of the Draper factory housing. Note the period clothing, gaslights, cedar shingles, unpaved street, and fieldstone curbs. (Photograph courtesy the American Textile History Museum, Lowell, Massachusetts.)

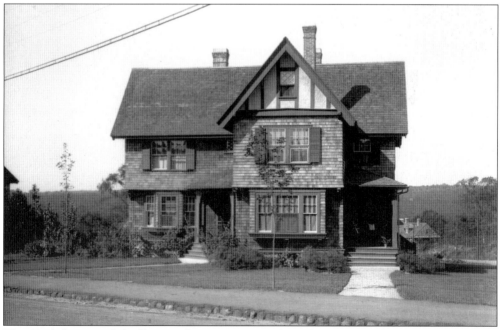

This English Revival dwelling at the intersection of Freedom and Northrop Streets was built c. 1913. The photograph was taken in 1915. Young trees, architectural detail, and a manicured lawn make this a fine example of a Draper worker double house. (Photograph courtesy the American Textile History Museum, Lowell, Massachusetts.)

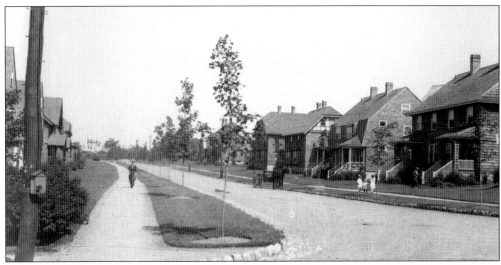

This early view of Hopedale duplexes on Jones Road, taken on August 2, 1916, includes tree belts with saplings showcasing the effort to create a gardenlike appearance throughout town. A group of small children, a horse and wagon, the man walking down the street, and the fire alarm box give a sense of life in the model company town. (Photograph courtesy the American Textile History Museum, Lowell, Massachusetts.)

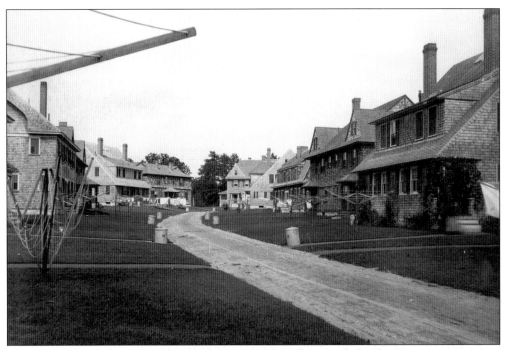

The inner core of Bancroft Park tells the story of the efforts made by the Drapers to maintain a neat and tidy outward appearance within neighborhoods. Clotheslines and trash barrels were all kept in the backyards, accessible by an alley for residents and town workers. (Photograph courtesy the American Textile History Museum, Lowell, Massachusetts.)

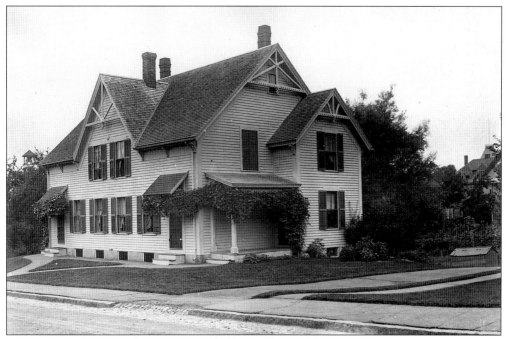

Longtime resident Dorothy Stanas recalled life in the model company town, noting some of the things the Drapers did for residents. "Light bulbs and fuses for our homes were supplied by Draper Corporation. Once a year, painters came in and did one room. If you wanted to do more, Drapers supplied the paint and paper. Our rent was four dollars a week."

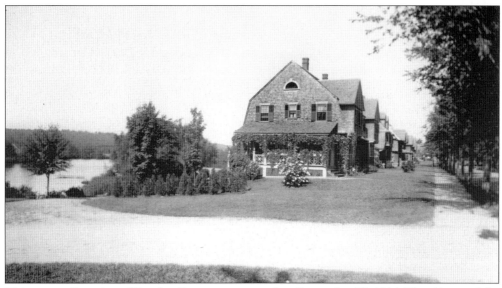

This outstanding view of Dutcher Street was captured on September 17, 1914. The glimpse of the elegant double houses and the beauty of Hopedale Pond from this angle remain largely unchanged today. (Photograph courtesy the American Textile History Museum, Lowell, Massachusetts.)

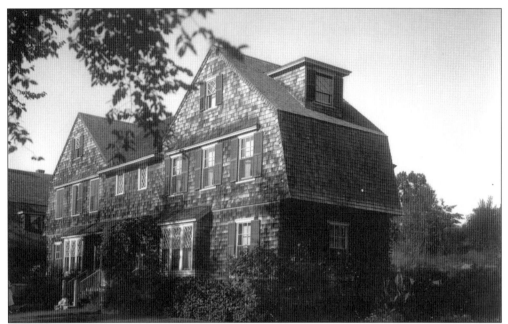

This double house at 131–133 Dutcher Street, known for its unique shape, was photographed in September 1919. The cedar shingles and well-maintained lawn reflect some of the beautification effects of the Draper Company. (Photograph courtesy the American Textile History Museum, Lowell, Massachusetts.)

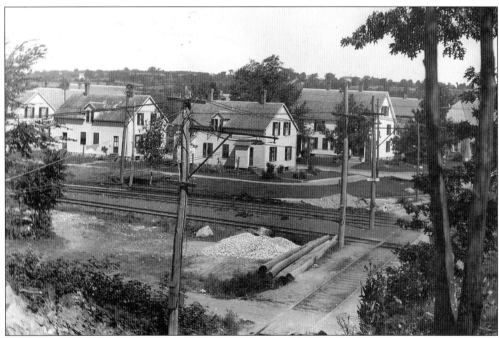

These homes on Freedom Street were commonly known as the Seven Sisters, as they were all identical when built. Taken from the Draper Field area, this photograph shows the route of the trolley as it led toward Hopedale Pond.

Four

GRAND PROPERTIES

At the beginning of the 20th century, Hopedale's industrial wealth was nowhere more evident than along Adin Street, where members of the Draper family and other prominent mill owners and executives built ostentatious estates in parklike settings. Today, many of the old mansions are gone, although numerous fine homes remain. The original Victorian mansion owned by Governor Draper at what is now 55 Adin Street was razed and replaced by his son Bristow Draper with an imposing brick-and-stone manse copied from a property in Great Britain in the 1920s. Several mansions were leveled to build the town's schools and parking areas, while others were converted to multifamily homes or nursing facilities. The Eben Draper Bancroft home, which sat on the hill overlooking what is now the entrance to Steel Road off Adin Street, was torn down in the 1940s, but its stone walls and Adin Street granite staircase remain. The William Lapworth House, at 85 Adin Street, remains as one of the finest examples of high-style Queen Anne architecture in the region. Another survivor graces the corner of Adin and Mendon Streets, where Benjamin Helm Bristow Draper built a walled, Spanish-style sprawling estate, complete with red clay tile roof.

Other grand properties appeared elsewhere in town, including along Hopedale Street, Mendon Street, Freedom and Williams Streets. Nearly all of the builders took advantage of the readily available supply of local granite, which was used primarily for foundations, steps, and decorative walls.

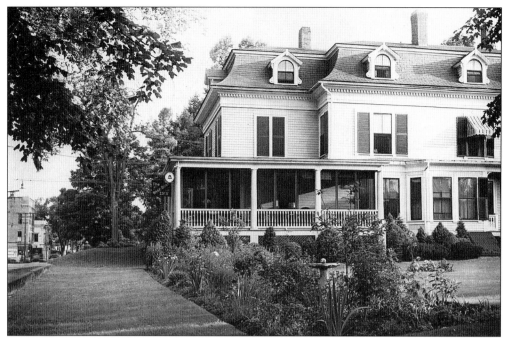

The Ebenezer D. Draper House was built at the corner of Hopedale and Adin Streets in 1856. Deacon Asa A. Westcott, proprietor of the Westcott Spindle Mills, purchased it in 1873. After his death, it was sold to the Draper Corporation and tenanted by Mr. and Mrs. Dana Osgood. Later, it served as the Brae Burn Inn. The last proprietors were Mr. and Mrs. Peter Caron, parents of the late Hilda Hammond. The building was demolished in 1958.

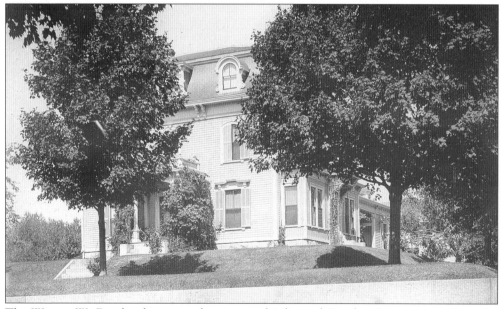

The Warren W. Dutcher house, at the corner of Adin and Dutcher Streets across from the General Draper High School, was erected in 1868. This mansard-roofed home was designed in the Second Empire style. For several decades, the building has served as a nursing home and is currently a multifamily dwelling.

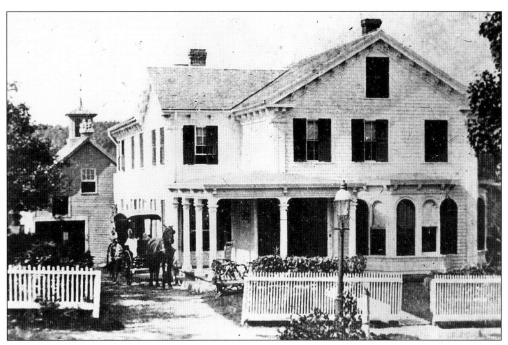

This very early view of the Joseph Bancroft house, at 48 Hopedale Street, shows it sometime after it was built in 1870. Bancroft was superintendent of the Draper business, later becoming vice president and, in 1907, president. Originally built in the Italianate style, the house underwent major renovations following Bancroft's death in 1909. This included altering the entire roofline, resulting in the Colonial Revival dwelling seen below.

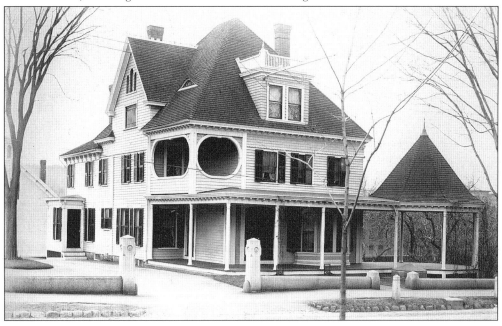

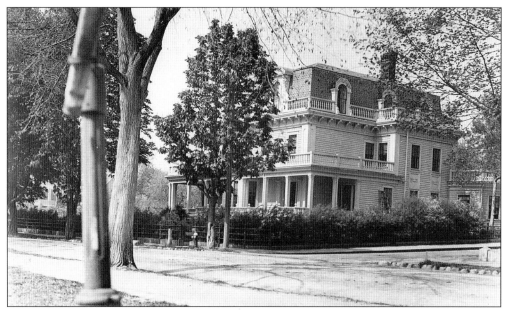

The George Draper house, also known as the Osgood house, was built in 1872. (Draper's daughter Hannah Thwing married Osgood.) It was designed in the Second Empire style, and was a two-and-a-half-story mansard-roof dwelling. Located at the corner of Hopedale and Draper Streets, it was demolished in 1923 to clear the site for the building of the Hopedale Community House.

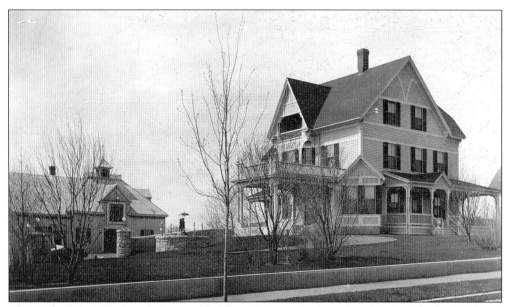

This Italianate Victorian home at 85 Adin Street, seen here *c.* 1890, was built for elastic webbing patent holder William Lapworth and his family *c.* 1875. In 1900, the Lapworths expanded and greatly changed the home, which they called Urncrest, adding high-style Queen Anne detailing, including a three-story tower and an Ionic-columned wraparound porch. The carriage house in the rear of the property retains its original Italianate character.

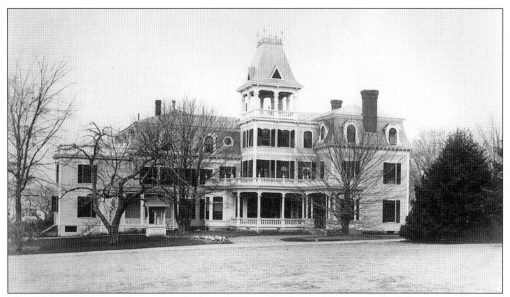

The William F. Draper house was built in 1879 in the Second Empire style. The two-and-a-half-story mansard-roof home, located on Adin Street at the foot of Dutcher Street, was razed in 1927 for the construction of the town's second high school, the General Draper High School.

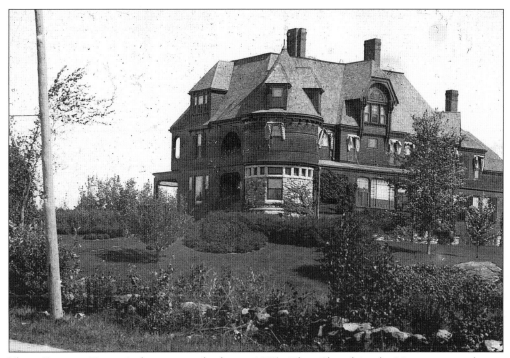

Eben Sumner Draper's house was built in 1885. This Shingle-style Victorian residence, designed by Boston architect George R. Clarke, was set on an estate of 60 acres at 55 Adin Street. Draper served as lieutenant governor of Massachusetts and later served a two-year term as governor. His house was later demolished and replaced with an English Revival–style home.

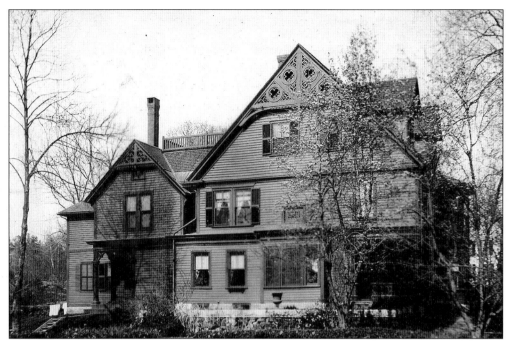

This picture shows the original residence of Frank Dutcher at 34 Adin Street. It was struck by lightning, burned down, and was then replaced by the Shingle-style dwelling shown below.

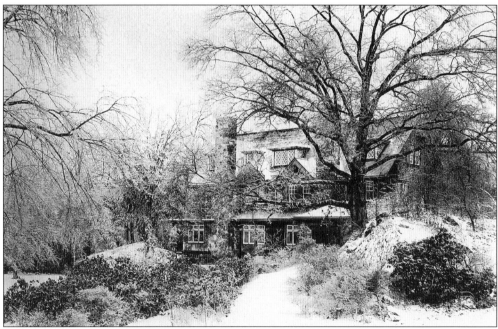

"On Christmas Eve the Dutcher house on Adin Street [No. 34] would have a lighted candle in every window. These were real candles. I do not recall any other house having illumination of this kind, and it was a pretty and dignified display," recalled resident Charles Merrill in his *Hopedale as I Remember It* essay looking back at his arrival in town in 1910. This structure has recently been used as a nursing home.

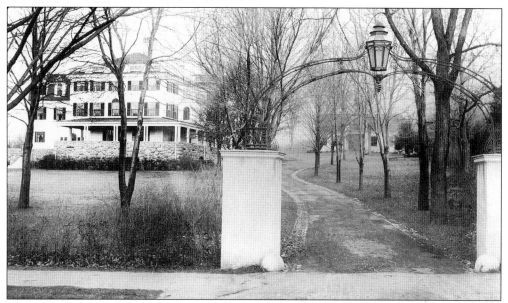

This Adin Street mansion was the home of Charles and Frances Eudora (Draper) Colburn. Frances was the sister of William F., George Albert, and Eben Sumner Draper. Memorial School now stands on this site.

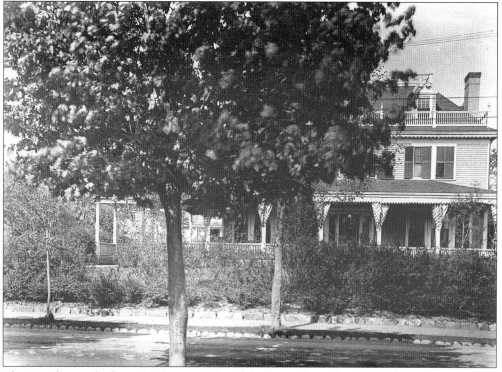

The Day house, built in 1890 across Hopedale Street from the Bancroft Library, is of the Colonial Revival style. The carriage house built in the same year is also of the same type. This house replaced the bungalow of Almon Thwing, an early resident, who, it is said, hid escaped slaves on their way to freedom. The picture was taken in 1903.

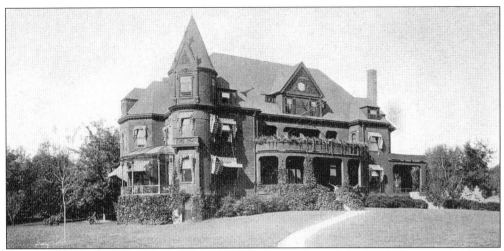

The George A. Draper house (George A. was the son of George) was located at 66 Adin Street, across from his brother Eben S. This large Queen Anne–style dwelling was designed and built in the early 1890s by Boston architect J. Pickering Putnam. It was eventually replaced by the existing brick French Eclectic home, the Benjamin Helm Bristow Draper Jr. house.

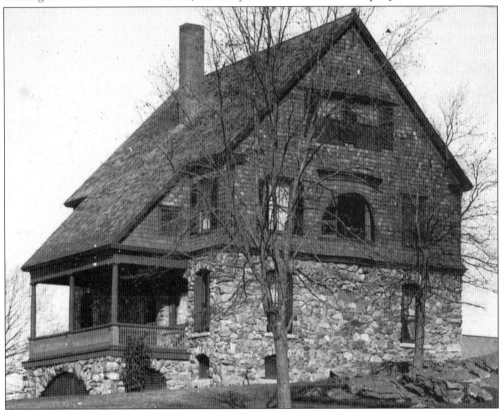

The Hopedale village has few remaining large-scale examples of the Shingle-style Queen Anne. A survivor, however, is the Charles Roper house, located at 50 Freedom Street. It was built c. 1890. This home is two and a half stories, with a cross-gable roof, fieldstone exterior on the first floor, and wood-shingle siding above.

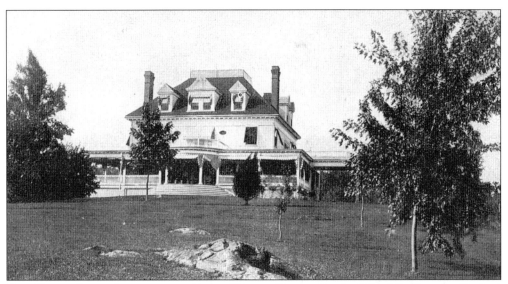

Eben Draper Bancroft was vice president of Draper Corporation in 1921. His Georgian Revival mansion was designed in 1896 by Robert Allen Cook and was demolished in the 1940s. Stone walls at the end of Steel Road where it meets Adin Street are remnants of this estate.

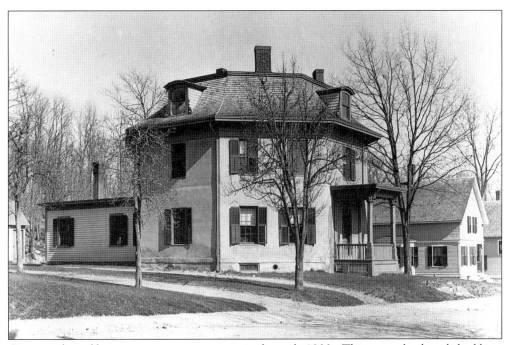

Octagon-shaped houses were not uncommon in the early 1900s. This example, demolished long ago, was located at the intersection of Prospect and Peace Streets.

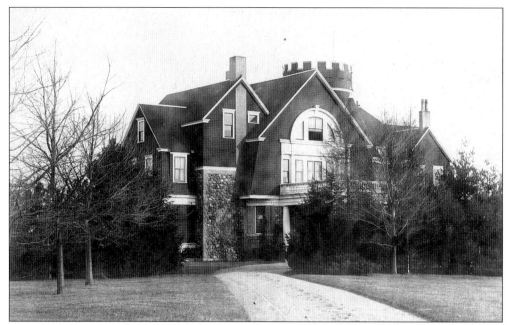

The original George O. Draper (son of William F. Draper) house, located on the Milford line on Williams Street, is shown here. This home was destroyed by fire in 1909, as evidenced in the lower photograph.

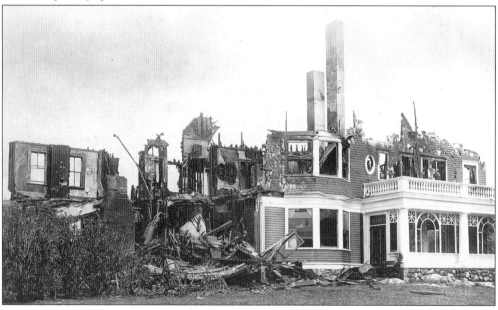

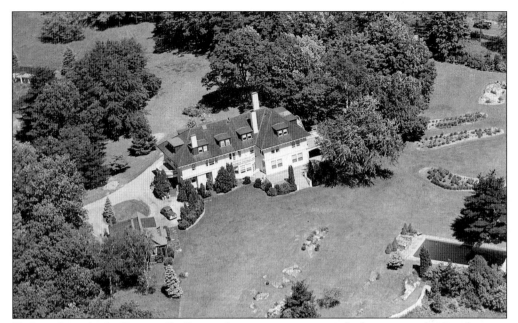

Today, the rebuilt George O. Draper house, more commonly known as the Larches, on Williams Street, serves as a community care center. The building is a fine example of Colonial Revival and Craftsman elements in a single design on a large scale. This aerial photograph provides a glimpse of the beautiful estate on which it sits.

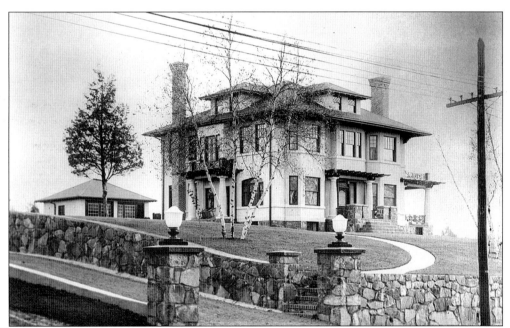

The Waldo W. Jenckes house, at 56 Mendon Street, is an outstanding example of a Craftsman-style stucco home. Built between 1911 and 1913, it features a trellised hood over the center entry. The hood continues over a long side porch supported by stucco columns. The architect was Frank T. Eskrigge of Boston.

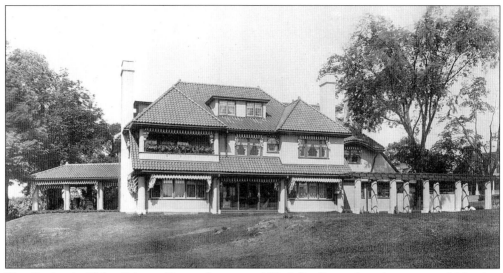

The Benjamin Helm Bristow Draper house, at 105 Adin Street (on the corner of Mendon Street), was built *c.* 1910. The stucco dwelling is Craftsman in style, and the red tile roof gives a Spanish Eclectic air. It has a hipped roof with open curves and an overhanging second story on the façade. A similarly styled carriage house was erected that same year. The Dillon Brothers of Milford built both.

Neatly tended lawns and gardens were a sign of the times in turn-of-the-century Hopedale. Here, the gardens of the Brae Burn Inn, at the corner of Adin and Hopedale Streets (now a parking lot for the high school), were a model of simplicity and elegance.

Five

PUBLIC BUILDINGS
AND SPACES

Hopedale's citizens have been the beneficiaries of many fine public buildings, nearly all of which were provided to the town by Draper family members. The town boasts a Richardsonian Romanesque-styled brownstone and granite town hall featuring an interior with detailed oak trim and stained-glass windows; the stately columned Hopedale Community House; and the solidly built and utilitarian fire station on Dutcher Street. They also provided several of the town's school buildings.

The Drapers took care of their employees, body and soul. They erected the current Unitarian Church on Hopedale Street (including two magnificent stained-glass windows designed by the Lois Comfort Tiffany Studio in New York) and built the Draper Hospital just over the town line in Milford (now known as the Milford-Whitinsville Regional Hospital). The last public building came in the 1950s, when the George Albert Draper Gymnasium was constructed on Dutcher Street.

In 1898, the Bancroft Memorial Library, built by Draper executive Joseph Bancroft in memory of his wife, Sylvia, was dedicated. Several years after the library's dedication, Susan Preston Draper donated a magnificent marble statue, the Statue of Hope, to the town. The statue, on the library grounds, fell prey to the elements over time but was restored in 2000.

Hopedale's citizens, then and now, also enjoyed fine public spaces, such as the Town Park on Dutcher Street, the Adin Ballou Park on Hopedale Street, the Parklands off Hopedale and Freedom Streets, the Draper Field off Bancroft Park, and the scenic and serene Hopedale Village Cemetery, where many members of the town's prominent families were laid to rest.

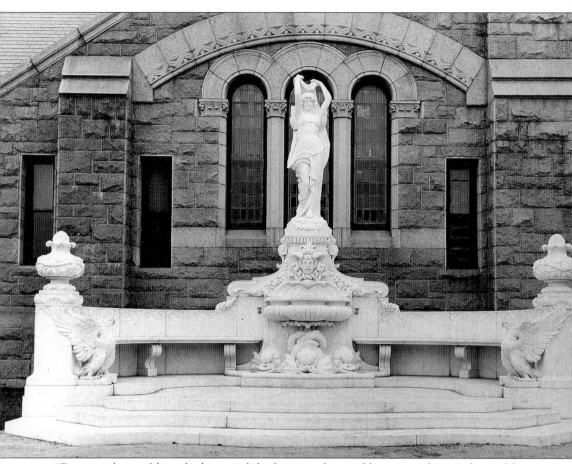

"For several years I have had in mind the leaving of a suitable memorial in our beautiful town, and I have felt that something artistic would be desirable, as you are sure to provide yourselves with everything that is needed of a practical character. Being well acquainted with the eminent and representative American sculptor in Rome, Waldo Story, I took his advice, and that of others, and decided that a fountain, surmounted by a statue of Hope, would be a suitable embellishment of the town of Hopedale. Artistically I think it is a great success, and I believe the time will come when people will come from far and near to see and admire it. As a Southerner by birth I have given less thought to the utilitarian side, but I hope that the cups of water here furnished will refresh many a tired mechanic or schoolboy in long years to come."
—Susan Preston Draper in a statement presenting the Statue of Hope to the town of Hopedale in 1904. The statue is located adjacent to the Bancroft Memorial Library on Hopedale Street.

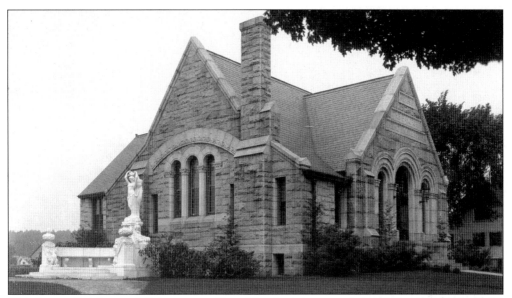

The Bancroft Memorial Library on Hopedale Street, erected in 1898, was designed by C. Howard Walker of Boston. Joseph Bancroft had it built in memory of his wife, Sylvia Thwing. It was constructed of Milford granite in the Romanesque Revival style. The bluestone walkways leading to the Statue of Hope were designed and completed by landscape architect Warren Henry Manning in 1906. (Photograph courtesy the American Textile History Museum, Lowell, Massachusetts.)

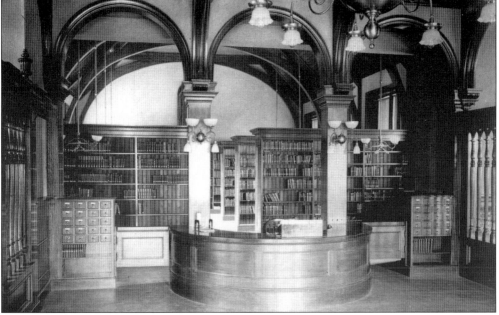

The interior of the Bancroft Memorial Library is well known for its beautiful oak finishes, particularly the ceiling trusses. The impressive semicircular front desk remains the focal point when one enters the building. Of special note here are the small doors leading to the book collection, ornate gas light fixtures above, card catalog files on both sides, and the hardwood floors throughout. (Photograph courtesy the American Textile History Museum, Lowell, Massachusetts.)

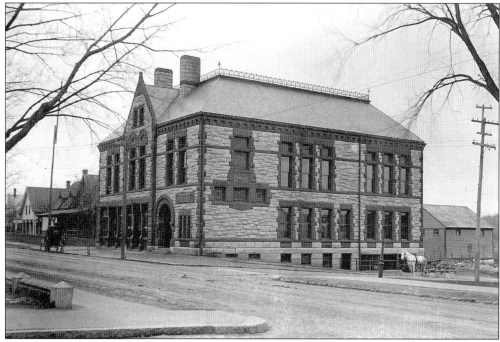

The town hall was built of brownstone and Milford granite in 1887 by George Draper and then donated to the community. Unfortunately, Draper passed away before the dedication of the building. Architect Frederick Swasey, whose trademark was ornate roofline grillwork, designed the Romanesque building. Over time it has housed—in addition to town offices—a barbershop, a dentist's office, a meat market, the post office, and various restaurants.

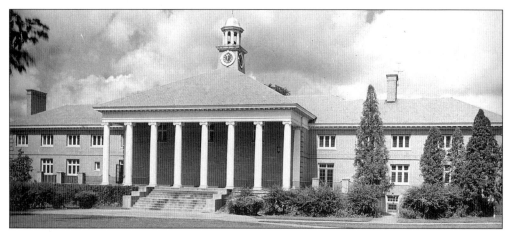

The Hopedale Community House, funded by George A. Draper, was designed by Edwin J. Lewis Jr. of Boston and was built in 1923 by the Casper Ranger Construction Company. The Colonial Revival design features a slate roof capped by a clock tower. Other features include the projecting frontispiece on the brick façade with double height Ionic columns, grand staircase, and a wrought-iron balcony on the northern elevation.

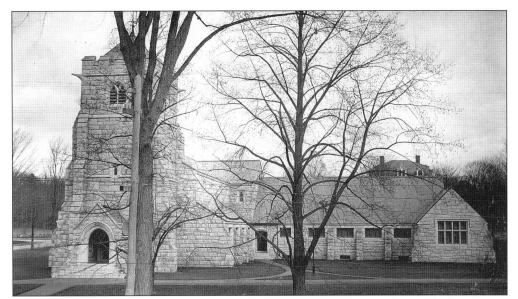

The Unitarian church was erected in 1898 by George A. and Eben S. Draper in memory of their parents, George and Hannah Draper. "My love affair with this church began when, as a young bride, I attended my first service with my husband. Sitting here on a Sunday morning listening to the sermon while drinking in the beauty of 'The Good Shepherd' stained glass window was and still is, inspiring," recalled Thelma Lapworth Shaw, church member.

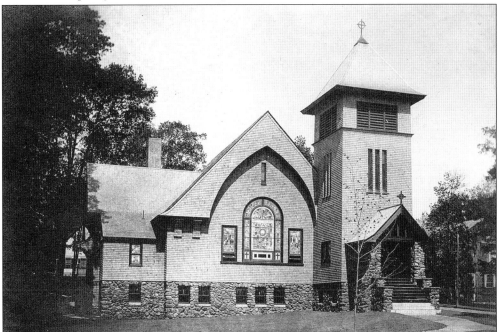

Robert Allen Cook designed the original Union Evangelical church, built in 1906, at the corner of Peace and Dutcher Streets. "My early memories . . . include a minister's wife who had us to the parsonage for hot chocolate. We will never forget taking our daughters down the aisle for their baptism with one on each of my arms. The Union Church is where I started playing the organ," remembered Hopedale resident Arthur Allen.

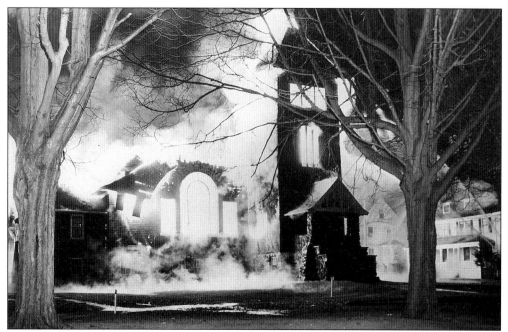

On a Saturday evening in December 1962, the Union Evangelical church on Dutcher Street was engulfed in flames and completely destroyed by fire. The lower photograph, taken the morning after, shows the burnt-out remains of the once beautiful stone-and-shingle structure. Ironically, the church had just undergone renovations, and a rededication had been scheduled. A more modern Union church structure has been erected on this site.

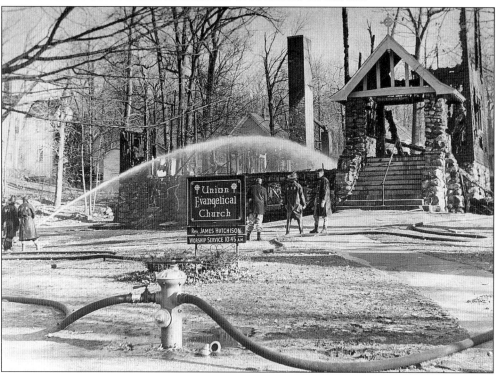

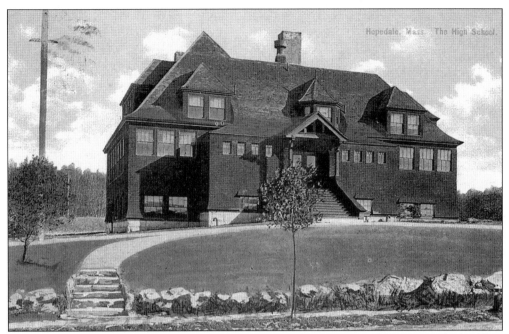

Sacred Heart Church opened in 1935 in the old high school on Hopedale Street. The building was razed in 1987. "Mrs. Jenny Chapdelaine played the organ. The choir was composed entirely of high school kids. During Lent, Mrs. Anna St. George and Mrs. Bracci would make breakfast for those who attended daily Mass. Then we'd walk to Patrick's Corner to get the bus to school at St. Mary's in Milford," recalled parishioner June Malloy Wright.

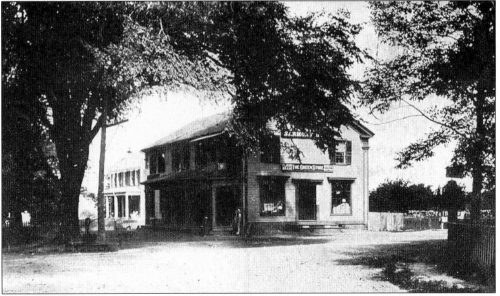

This building, situated at Route 140 and Hartford Avenue, was known as the Green Store. It was built c. 1780 and operated as a general store from that time until 1917. From 1814 until 1914, it also housed a post office. The first straw bonnets manufactured in New England were made there c. 1810. The Chapel Association bought it in 1910, and it has been used as a church since that time.

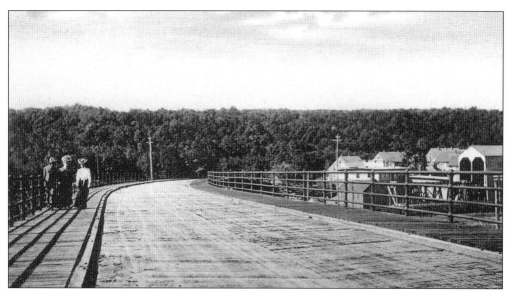

The Hope Street Bridge played an important role in Hopedale's history. Passing over several sets of railroad tracks and other Draper facilities, it linked the east side of town to Hopedale Coal and Ice, the Hopedale Village Cemetery, Bancroft Park, and Cemetery Street. Eventually, the bridge was deemed unsafe, and it was dismantled in 1979.

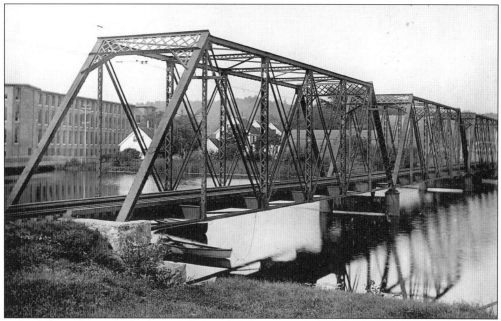

The trolley was a popular means of transportation. Originating in Framingham, it traveled through Milford, up Route 16, turned right onto Hopedale Street, crossed Hopedale Pond, and ended in Uxbridge. Operations ceased in the late 1920s. The Draper plant can be seen behind the bridge. "I remember riding the street car in summer over Hopedale Pond. It was an open car with cane or straw seats," recalled resident Dorothy Stanas.

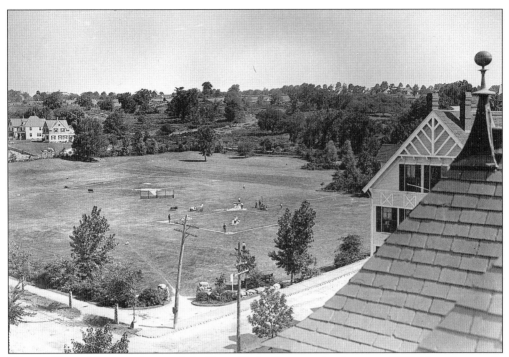

Warren Henry Manning designed the Town Park. Construction began *c.* 1890. Covering nearly six acres, it is located at the corner of Freedom and Dutcher Streets. A marshy area was drained and graded, and loose stones on the property were used to create stone walls. Over the years, the park's amenities have included tennis courts, hurdles, a bandstand for weekly concerts, and a baseball diamond.

The entrance to the Town Park at the intersection of Dutcher and Freedom Streets is seen here. Young trees, protected by caging, reveal that this is a very early photograph.

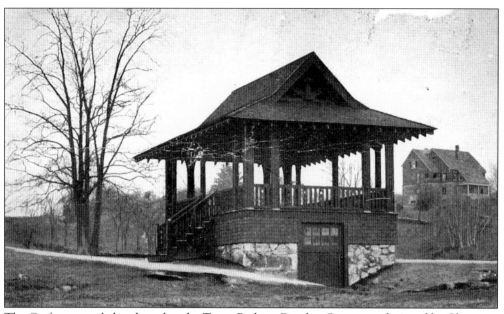

The Craftsman-style bandstand at the Town Park on Dutcher Street was designed by Chapman and Fraser of Boston. It was built by the Dillon Brothers of Milford in 1906 and included a locker room below. The Hopedale Brass Band was formed in the same year.

In 1899, the Parks Commission, Frank Dutcher, Charles Roper, and George O. Draper accepted a proposal by Warren Henry Manning, landscape architect (believed to be the gentleman in this photograph) to develop a park of nearly 200 acres along the "Upper Privilege" shoreline area of Hopedale Pond. The town appropriated $14,000 for the project, which was designed to keep the pond and park "as natural as possible, to refuse any touch of artificiality." (Photograph courtesy the American Textile History Museum, Lowell, Massachusetts.)

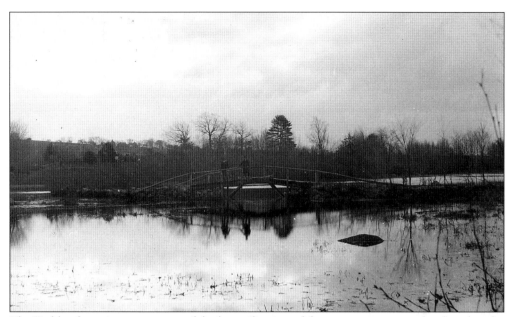

The Parklands, an important part of the beautification of the community, were developed in the early part of the 20th century. Monies in the amount of $2,500 a year were spent on this project. The quaint wooden bridge shown above, known as the Rustic Bridge, was eventually replaced with one of stone. This scenic area is used regularly for fishing, walking, jogging, and picnicking.

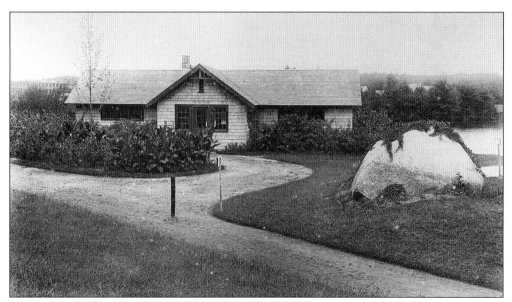

In 1899, a bathing beach was created at the southern end of the Parklands, near the intersection of Hopedale, Dutcher, and Northrop Streets. Sand was dumped on the ice during the winter. This settled to the bottom to form the beach. The bathhouse seen here was designed by Chapman and Frazer and was added in 1904.

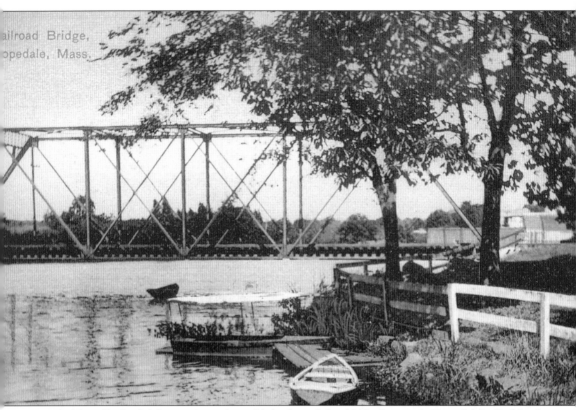

A *New England Magazine* article published in July 1909 discussed Hopedale's Parklands. "Hopedale covers in all, about thirty-five hundred acres, and of this area nearly one thousand acres are set aside for the use of the general public, who derive the freest benefit from this preservation and improvement of the landscape. Some 50 boats and canoes may be found upon the pond, and we who haunt its rippling waters and shady nooks, know and love the gleaming birches and stately pines, the pretty rustic bridge and beckoning pathways, the clear, cold springs, and the winding stream through the marshes—while the merry shouts of the youngsters which fill the air of the summer evenings, leave no room to doubt their appreciation of the bath-house with its careful attendant. We of small holdings are indeed rich in our out-of-door privileges."

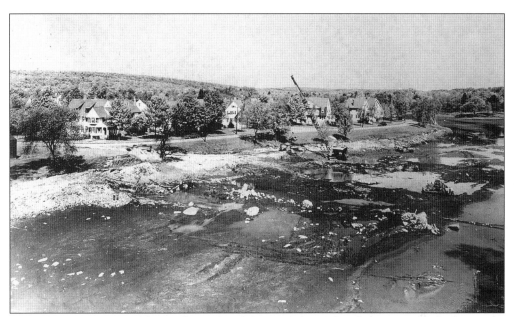

In the late 1940s, Hopedale Pond was closed for several months while it was dredged. In order to drain it, a dam was built about a half mile upstream from Freedom Street. When the project was completed, about half of the dam was removed, but the eastern half was left in place and is still visible today.

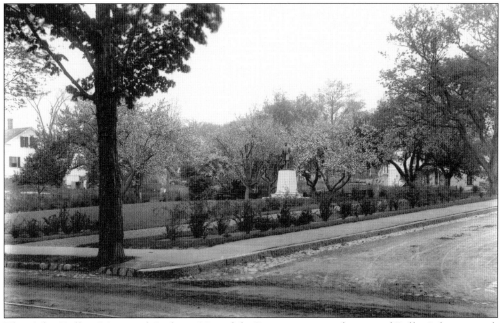

The Adin Ballou Memorial Park on Hopedale Street occupies the site of Ballou's homestead, from which he published the *Practical Christian,* the community newspaper. Gen. William F. Draper donated the statue of Adin Ballou. William Ordway Partridge of New York was the sculptor. A dedication took place on October 27, 1900. *New England Magazine* in 1909 stated, "Adin Ballou may well be called the patron saint of the village." (Photograph courtesy the American Textile History Museum, Lowell, Massachusetts.)

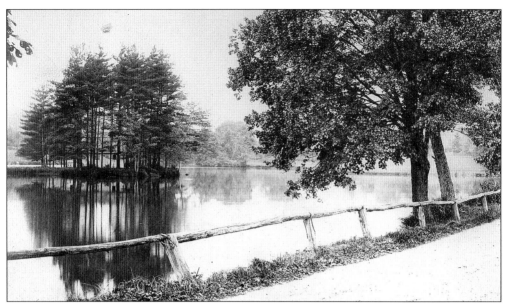

The Spindleville Pond is shown from Green Street. Resident Roberta Simmons recalled life around the pond, saying, "I've lived in eight different houses on Mill Street. In the winter we'd skate on Spindleville Pond and build a fire on the ice and roast hot dogs. I'd use Uncle Ray's [Westcott] boat on the pond in the summer."

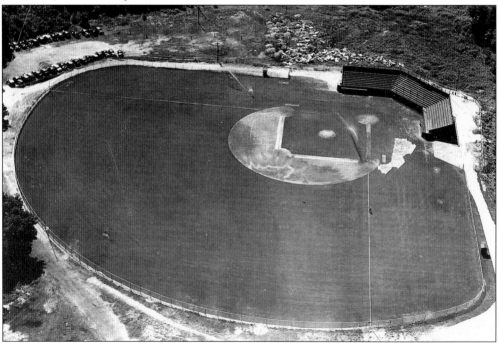

Draper Field opened in 1948 on what had been four acres of swampland. It was built for the Draper team that played in the Blackstone Valley League. The opening-day game against Whitinsville attracted an overflow crowd of 1,686. The park contained an underground sprinkler system, duplicating one at Braves Field in Boston, and lights for night games. In Massachusetts, Draper Field was said to be second only to Fenway Park at that time.

Six

SCHOOL DAYS

The first school established in Hopedale was built *c.* 1790 near the South Hopedale Cemetery on Plain Street. It was replaced in 1813 with a new school, and finally a third school was built just north of the cemetery in 1855. For some years, children in that part of town attended the South Hopedale School through grade six; older children took the trolley to schools in the center of town.

When Adin Ballou arrived in 1842, an early utopian community project was to erect a building that would serve as a chapel and school. It was on Hopedale Street between Freedom and Chapel Streets. In 1854, Mr. and Mrs. Morgan Bloom opened a boarding and day school called the Hopedale Juvenile Home School. In 1856, they sold it to William and Abbie Heywood. Abbie was Adin Ballou's daughter, and she became a very popular teacher at the school.

The Chapel Street School was built in the late 1800s and, along with the Dutcher and Park Street Schools, housed elementary students. Today, the Chapel Street School is gone, and Park Street School houses the Bright Beginnings Center. The Dutcher Street School, built in 1898, is now the elegant Uncommon Place condominiums. Elementary students today attend the Memorial School on Prospect Street.

In 1887, a high school was built on Hopedale Street. It was used until 1927, when students began attending the General Draper High School on Adin Street, built on land where the general's home once stood. That school is still in use today, although it has undergone additions and a transformation into a state-of-the-art facility.

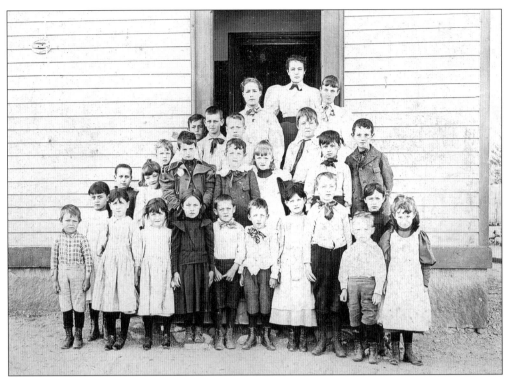

In *A History of South Hopedale*, Elsie L. Jenks notes that this school on Plain Street in South Hopedale, across from Rosenfeld's Concrete and north of the cemetery, was constructed in 1855. The site cost $60.12. The building was erected for $1,491. Two earlier schools had been built in this area, the first *c.* 1790. The teacher in this late-1800s photograph is Henriette (Wenzel) Warfield. (Photograph courtesy David and Karen Warfield.)

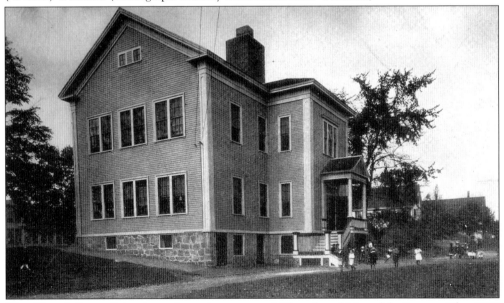

The Chapel Street School stood on the corner of Chapel and Hopedale Streets. The 1920 Sanborn map refers to it as the "Sub-Grammar School." It was demolished in the 1950s.

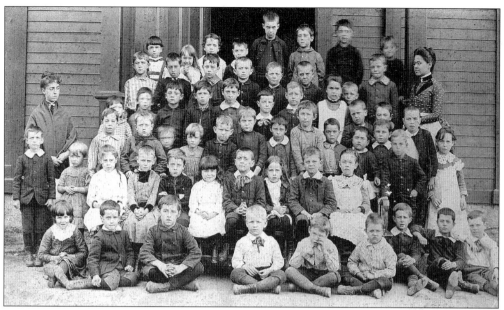

The first-grade class at the Chapel Street School is featured in this late-1880s photograph.

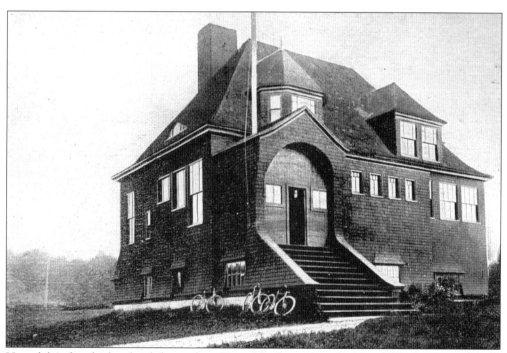

Hopedale's first high school, located on Hopedale Street, was built in 1887. It was used until 1927, when the General Draper High School opened. Eventually, the old school was sold and became the first Catholic church in town. Razed in 1987, this site became the parking lot for Sacred Heart Church.

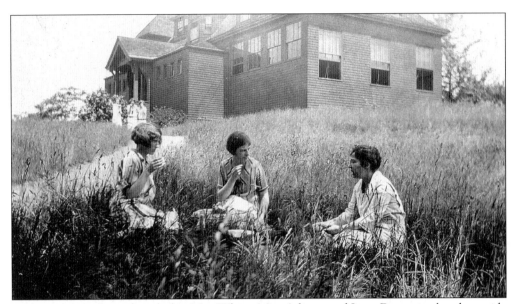

High school teachers identified as Miss White, Miss Adams, and Lucy Day enjoy lunch outside the old high school on Hopedale Street. Warren Henry Manning, an associate of famed landscape architect Frederick Law Olmstead (who designed Central Park in New York and several public spaces in Boston), developed and executed a grading and planting plan for the grounds in 1889.

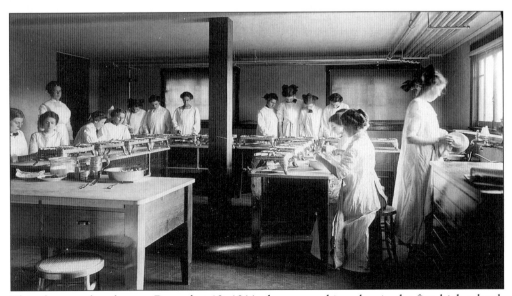

This photograph, taken on December 12, 1911, shows a cooking class in the first high school, on Hopedale Street.

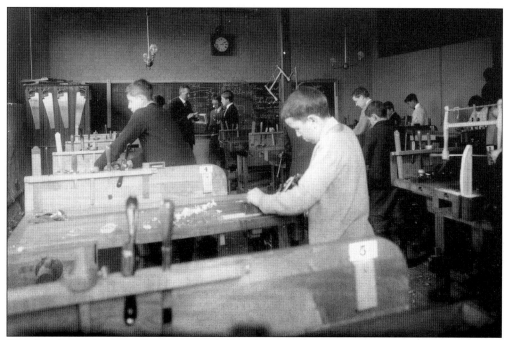

Woodworking was an important part of the educational program. This manual training class was photographed in the first high school. (Photograph courtesy the American Textile History Museum, Lowell, Massachusetts.)

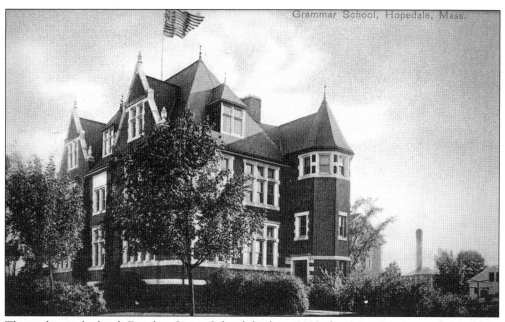

Grammar School, Hopedale, Mass.

The gothic-style, brick Dutcher Street School, built in 1898, features a massive and steep slate roof. Heating was provided through underground ducts from the Draper plant. After closing its doors as a school, the building was sold and divided into condominiums known as Uncommon Place. A primary goal of the current residents is to maintain its pristine, historic appearance.

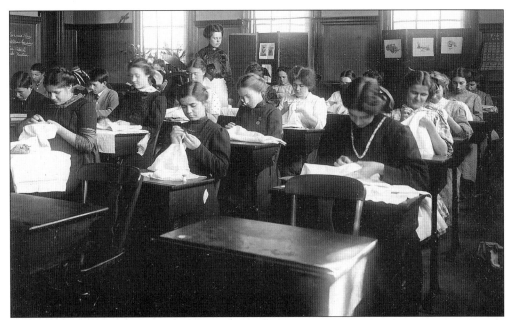

This photograph of a seventh-grade sewing class was taken at the Dutcher Street School in 1911. The students are, from front to back, as follows: (right row) Gertrude Spaulding, Effie Munyun, unidentified, Elsie Jenks, unidentified; (center row) Grace Dow, Gladys Davis Grant, ? Goff; (right row) ? Johnson, Mary Finley, Gwendolyn Beal, unidentified, Margaret Bottomley. The boys are Thornton Clark and Carlton Baldwin. The teacher is identified as Miss Knight.

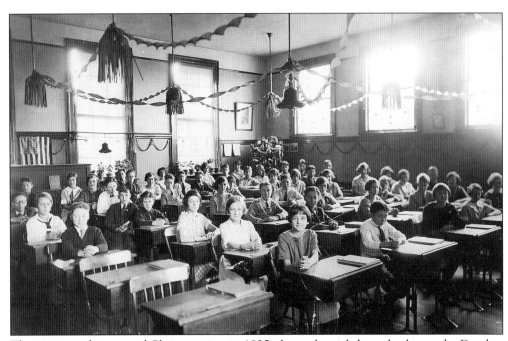

This picture, taken around Christmastime in 1925, shows the eighth-grade class at the Dutcher Street School.

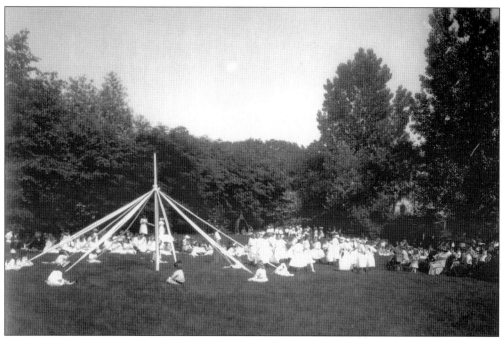

The Maypole dance, once a popular springtime activity to celebrate May Day, is now but a memory. Hopedale schoolchildren are seen here enjoying the event at the Town Park in 1913. (Photograph courtesy the American Textile History Museum, Lowell, Massachusetts.)

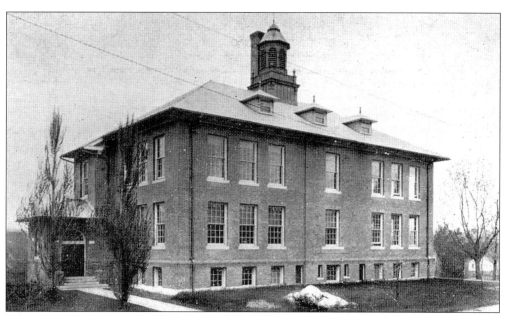

Frank Kendall designed the Park Street School, built in 1914 in the Colonial Revival style. This and other buildings constructed in Hopedale in the early 20th century were the result of the success and expansion of the Draper Company and met the needs of the growing town.

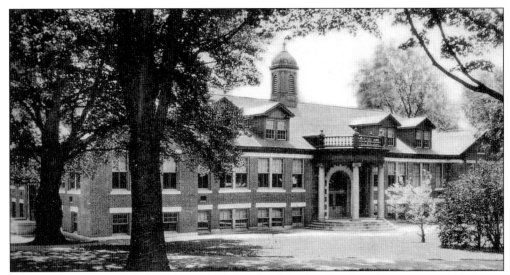

The stately General William F. Draper High School, built of brick and cast stone in 1927, was designed by C.R. Whitcher of Manchester, New Hampshire. The Colonial Revival–style school is one and a half stories on a raised basement, with a hipped roof, gabled dormers, and a cupola. Centered on the façade is a semicircular portico with full height Ionic columns. It retains much of its original exterior character today.

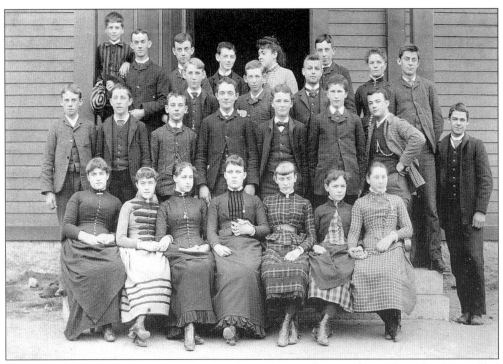

Lilla Bancroft Pratt was the teacher for this class. Glenis Bishop Hachey, Class of 1957, recalled of her own school days, "We were inspired by [our teachers'] commitment toward education. The principles taught and examples given will remain firmly embedded in the minds and hearts of all who graced the halls of Hopedale High School. . . . We are forever grateful to the faculty."

Seven

LIFE AND LEISURE

Hopedale today is a bedroom community with little industry, but the hulking Draper complex near the town's center is an omnipresent reminder of the hard work that took place there. To relax after working six days a week, early residents enjoyed a variety of activities. Some spent time in their well-tended yards, while others strolled the paths of the peaceful Village Cemetery. Surely, there were those who visited the Statue of Hope at the Bancroft Library or met at the statue of Adin Ballou in the Adin Ballou Park to read his words of wisdom.

Perhaps the most desirable spot for solace in Hopedale then and now is the Parklands, a town-owned, 1,000-acre paradise designed by landscape architect Warren Henry Manning. Manning was an associate of Frederick Law Olmstead, who designed the landscapes of several Draper properties in Hopedale as well as more famous sites, including the Boston Public Gardens and New York's Central Park.

There were also larger gatherings of residents for events such as the annual field day. The band concerts at the Town Park were and remain a favorite summertime pleasure for residents.

Athletic competition was a major draw, with the beautiful Draper Field seating more than 1,500. Residents also participated in Hopedale Community House events, swimming, and boat races on the scenic Hopedale Pond, as well as community dinners. Sundays were a time of religious reflection as well, perhaps followed by a round of golf at the Hopedale Country Club off Green Street.

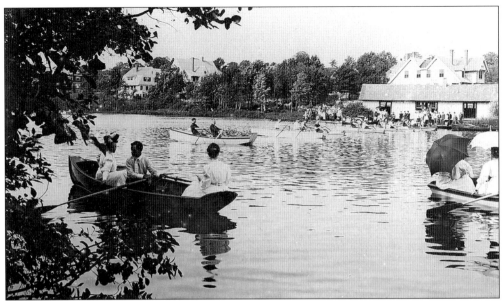

Resident Charles F. Merrill recalled that recreation was simple and inexpensive, and walks in the Parklands were a favorite diversion. "Many people had boats and canoes, and on weekends they might be seen paddling or rowing about the pond. In the fall, it was fun to gather chestnuts." The once abundant chestnuts were swept out of existence by blight in the early 1920s, causing the demise of the red squirrel population as well, Merrill said.

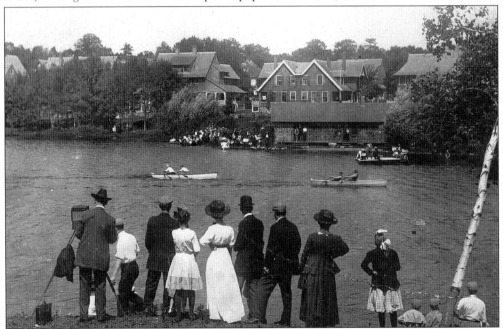

In the early years of the 20th century, the Drapers endeavored to provide the means for leisure activity. To that end, they widened the pond, created a beach area, built the Town Park, and developed the woodlands around the pond that became known as the Parklands. Boat races were a popular part of the annual field days. Here, a group of spectators, including a photographer, views the event from the Lake Street shore.

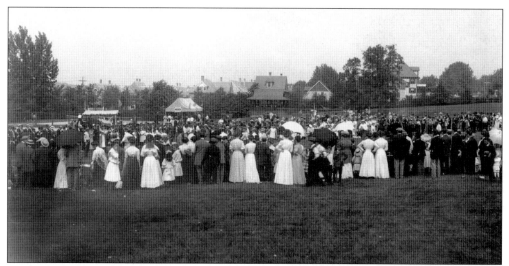

This image, captured on July 13, 1900, shows an early field day. The large number of attendees showcases the popularity of the event, which was held for all Draper employees. (Photograph courtesy the American Textile History Museum, Lowell, Massachusetts.)

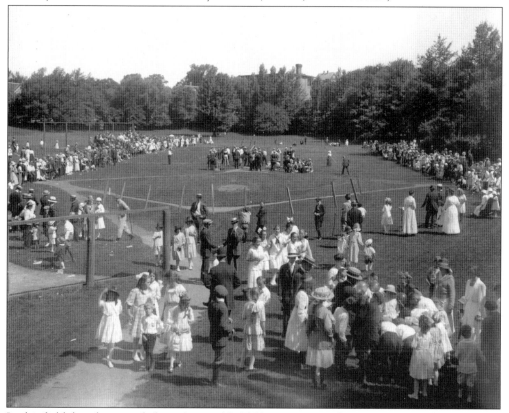

In this field day photograph from August 19, 1919, one can see the event remained popular year after year. In this close-up view of the crowd, it is interesting to note the changes in clothing style from the earlier view. (Photograph courtesy the American Textile History Museum, Lowell, Massachusetts.)

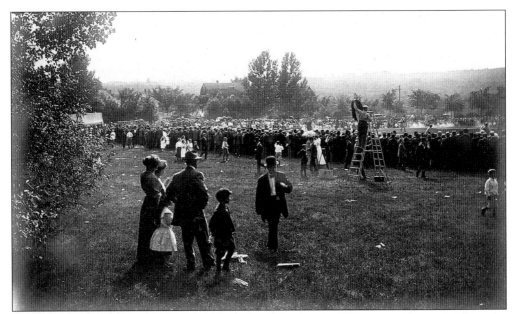

Spectators at an early field day are captured in this image. These events were held in the summer months, yet everyone is properly attired in the fashion of the day. In this photograph, a young family rests in the shade of a tree. Note the photographer standing on a ladder to get a better view of the activities.

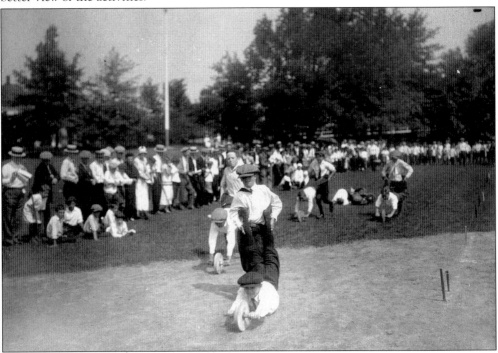

The wheelbarrow race was one of the many highlights at the annual field day event held at the Town Park. The wheels were probably made by Draper workers for the event. This memory was captured on August 1, 1924. (Photograph courtesy the American Textile History Museum, Lowell, Massachusetts.)

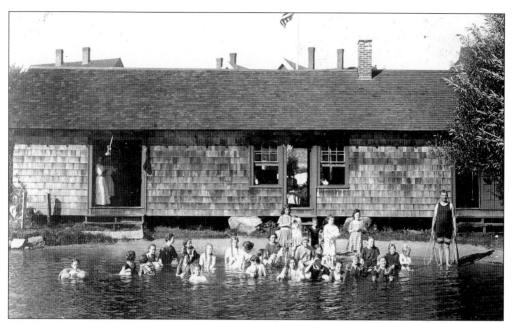

The beach at Hopedale Pond was created in 1899, and the bathhouse was built in 1904. According to records for 1905, "3,100 baths were taken by males, 222 by females." Women were only allowed to swim when a matron was on duty for supervision and men were not present. "No swimming in the pond or playing in the Town Park was allowed on Sunday," recalled resident Dorothy Stanas.

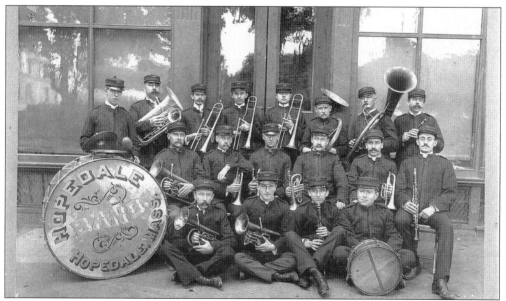

This photograph of the Hopedale Marching Band was taken in the early 1900s. The band took part in parades and concerts throughout the area. They are identified as Silas Staples, Sterling Freethy, Fred Osgood, Wesley Knights, Peter Gaskill, B. Manuel, W. Beals, William Nuttall, Victor Wise, Mr. Cole, Jesse Warren, Lyman Sweet, Warren Stimson, Walter Walson, Roscoe Seers, Daniel Warren, and Wilfred Scott.

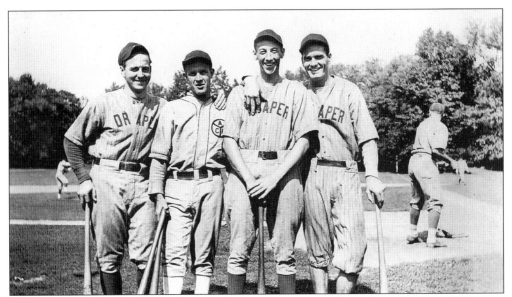

Mill owners in the region built baseball parks and organized a league known as the Blackstone Valley League. Shown on September 2, 1933, these Draper players are, from left to right, Pret Johnson, Norman Steel, William O'Brien, and Stenson Hattersley.

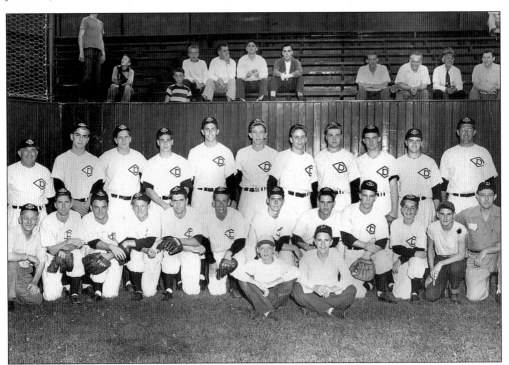

Former Boston Red Sox manager Joe Morgan (second from left in the front row) played for the Draper team from 1949 through 1951 and also played college baseball with Boston College. Speaking of his experience in Hopedale, he said, "You got a rude awakening in that league. . . . College ball wasn't as good as the Blackstone Valley League . . . no comparison." The batboy (sitting in front on the left) is Bob Moore.

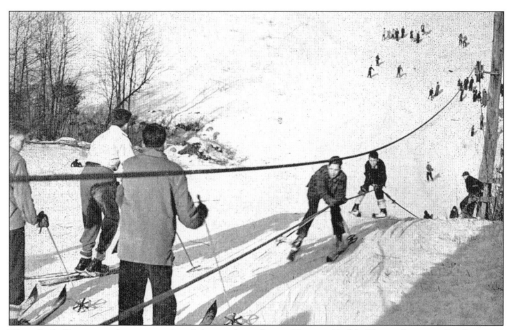

The ski hill was on the west side of the parking lot at Draper Field. "I am skiing today because of that old ski hill with the rope tow and my Sears special wood skis with one strap over the overshoes. Getting up the hill without losing the skis was as hard as getting down the hill. I never went down the front," remembered former resident Lynn Barry Lutz.

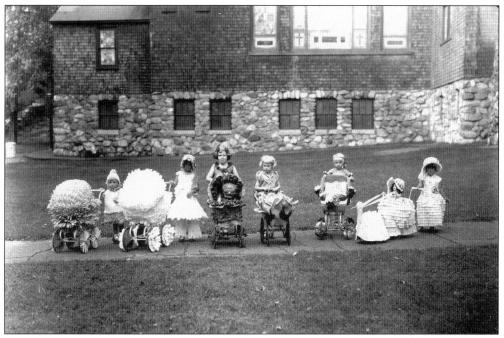

This photograph of children being readied for a doll carriage parade in the early 1900s was taken near the Union Evangelical Church on Dutcher Street. (Photograph courtesy the American Textile History Museum, Lowell, Massachusetts.)

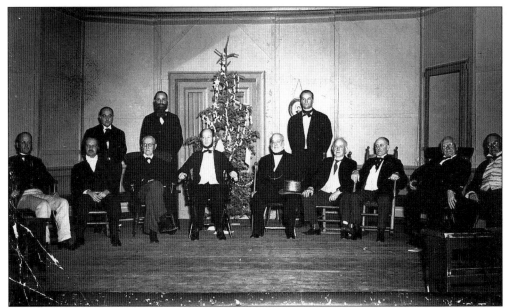

In January 1942, there was a pageant commemorating the 100th anniversary of the founding of the Hopedale community. The cast of the production, seated from left to right, includes Winburn Dennett, Ben Draper, Henry Smith, Mort Dennett (as Adin Ballou), H.A. Billings, Gard Allen, Howard Smith, J. Connolly, and William Lapworth. Standing, from left to right, are Mr. Scribner, Ed Lilley, and Edgar Hall Jr.

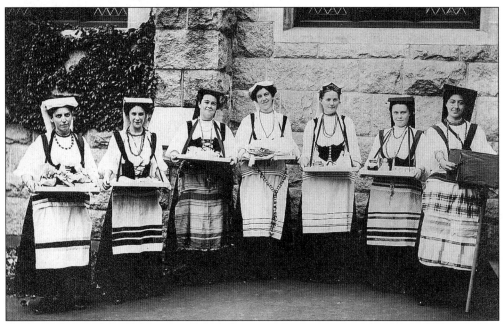

Workers costumed for a Unitarian church fair pause for a memory to be captured. From left to right are Mrs. Arey, Dorothy Pierce, Dorothy Draper, Edna Darwin, Lee Lapworth, Mrs. Davis, and Emma Kingsley.

The children seen here are identified as Theodore, Cory, and Patty Pratt.

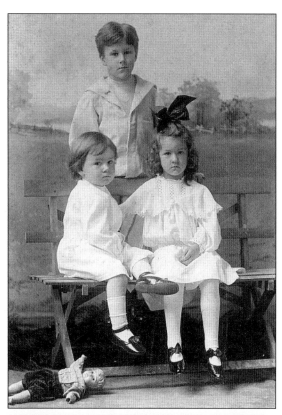

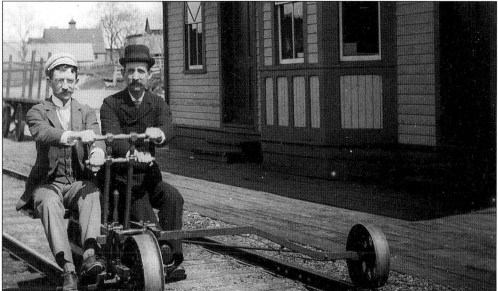

Two railroad workers pose on the handcar in front of the Grafton and Upton station. "I can remember stealing the handcar from the G & U yard with my best friend, Howie Felton. We'd pump it up the tracks to Upton and then race downhill back to Hopedale. Chief Kellogg would be waiting for us but we always got away. It was more or less an ongoing game," remembered former resident James F. Holt.

This photograph shows two gentlemen appearing relaxed on a summer's day, while the woman, still wearing her apron and perhaps reflecting on her unfinished chores, looks on.

Here, two ladies are seen sharing a ride in a splendid carriage on a summer's day.

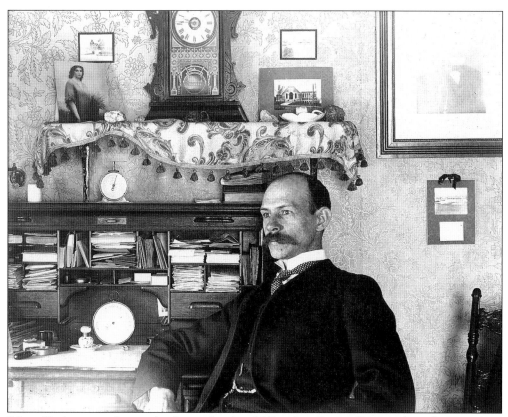

Edwin Darling, seen here in his home, lived at 54 Freedom Street. He served as selectman from 1895 to 1926. This photograph was taken *c.* 1901.

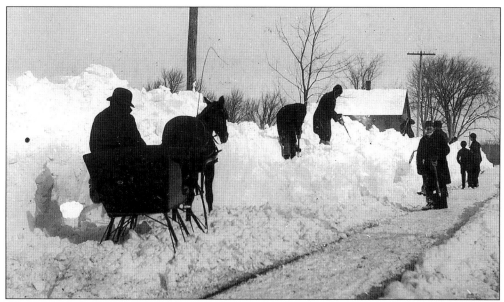

A winter scene in Hopedale shows the heavy drifts of snow and a horse pulling a sled. Unfortunately, the people are unidentified.

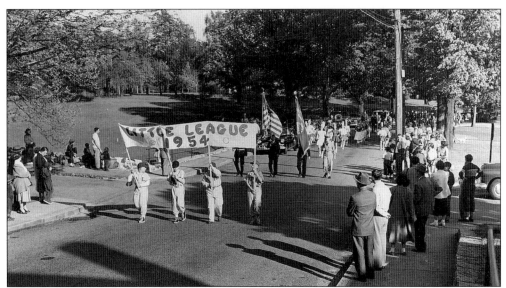

Little League has long been a popular pastime for Hopedale residents. This 1950s photograph shows the boys marching in the opening-day parade along Dutcher Street. The empty lot seen in this view is now occupied by the George Albert Draper Gymnasium.

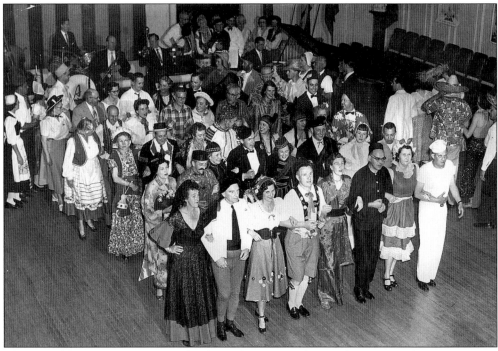

The Hopedale Community House has been the setting of many functions and activities since it first opened. Those in the Grand March at the International Ball in the 1950s are, from left to right, as follows: (first row) the Hamilton Thayers, the John Hutchinsons, the Paul Robertses, and the Freeman Hammonds; (second row) the Paul Grants, the Eldon Biggses, the Millard Lovejoys, and the Vincent Rubeos; (third row) the Henry Knights, the James Richardsons, Olive Bradbury, Ben Johnson, and the Mortimer Dennetts.

Eight
WORKING IN HOPEDALE

In its heyday, Hopedale was respected regionally, nationally, and even internationally for its textile loom-manufacturing plant. Over the years, the Draper Company employed thousands of skilled workers who performed a variety of functions, from manufacturing spindles and casting Draper-patented metal machine parts in the foundry, to designing, assembling, testing, and shipping the looms. Longtime residents still talk of the morning, noon, and evening bell that tolled to warn workers it was time to get to work in the morning and after lunch.

Although the Draper Company was omnipresent in nearly all facets of Hopedale life, there were other jobs to be had. The town hall at one time or another contained a doctor's office, a dental practice, a soda shop, the post office, and restaurants.

Some of Hopedale's residents made their living working for the town's dedicated police, fire, public works, water and sewer, and school departments. Other businesses also came and went, including the Hopedale Coal & Ice Company, which had an elaborate operation on Hopedale Pond to cut ice each winter for use throughout the year. The advent of the automobile helped spell the end for the Hopedale Stable. Northrop Street was once home to the Roper foundry, now long gone, and the Spindleville Mill employed many skilled workers over the years. Other businesses in town included various stores and restaurants, a gas station, a concrete business, a small airport, and even a penny candy store where children would gather after school.

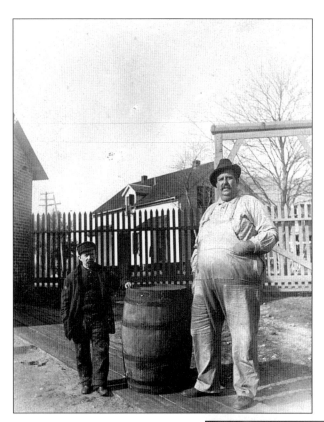

Taken on December 4, 1902, this photograph is titled "The Biggest and Smallest Men in Draper's." Mike Maloney stood 3 feet 11 inches tall, weighed 64 pounds, and was 52 years old. Horace Aldrich was 6 feet 4 inches tall, weighed 485 pounds, and was 42 years old.

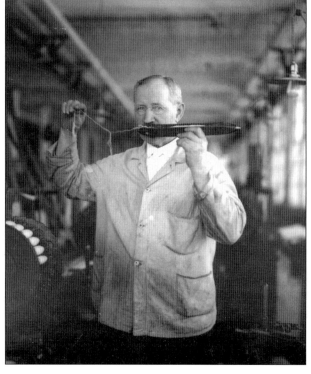

This photograph, entitled "Sucking Thread through the Shuttle Eye," shows a Draper Company employee with a shuttle doing just that. This process was called the "kiss of death," so named for all the excess lint inhaled by the worker. The image was taken on February 11, 1911. (Photograph courtesy the American Textile History Museum, Lowell, Massachusetts.)

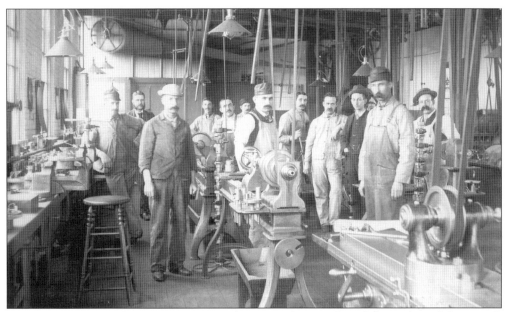

This group photograph shows Draper employees in the spindle-polishing shop. (Photograph courtesy the American Textile History Museum, Lowell, Massachusetts.)

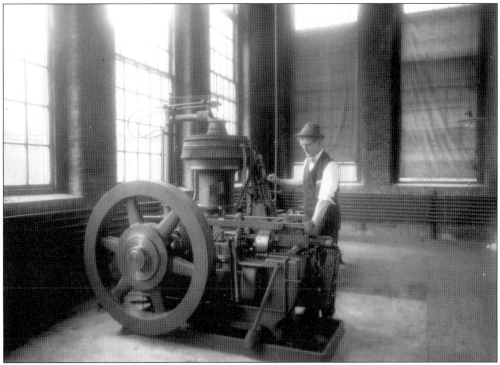

A Draper employee is seen inside the plant at a belt machine on September 28, 1909. His attire, white shirt, vest, and bow tie suggest that he may have been a foreman. (Photograph courtesy the American Textile History Museum, Lowell, Massachusetts.)

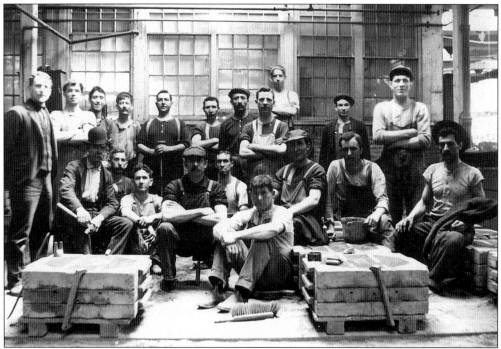

Hopedale resident Hester Chilson noted that the Draper workers had long days, working from 6:00 a.m. to 6:00 p.m. Monday through Friday, with one hour off for lunch. They would also work a half-day on Saturday, she recalled. Shown here is the foundry.

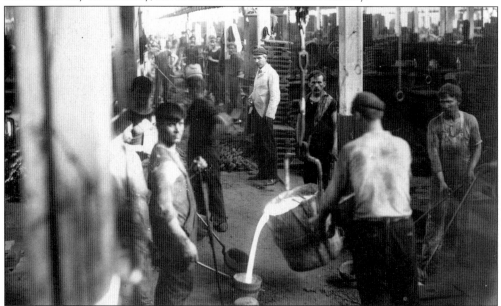

In this photograph, Draper workers pour molten iron in the shop's foundry. Foundry work was likely among the most difficult and physically challenging jobs at the plant. George Harlow, former plant manager, recalled the "old workers—Irish, Italian, Portuguese, and English," saying, "Whenever they'd enter my office, they'd take off their hats and refer to me as 'Mr. George.'" (Photograph courtesy the American Textile History Museum, Lowell, Massachusetts.)

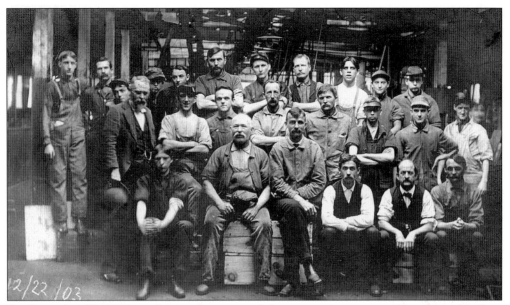

On December 22, 1903, workmen who operated the automatic screw machines assemble for a photograph inside the Draper plant.

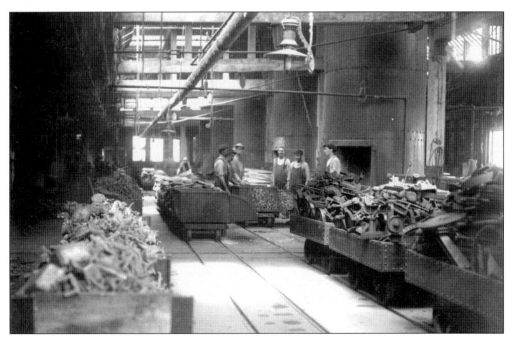

Draper Company foundry workers are seen here charging stacks on June 17, 1909. This process involved loading wood, coke, iron ore, and scrap iron into the kiln for smelting. (Photograph courtesy the American Textile History Museum, Lowell, Massachusetts.)

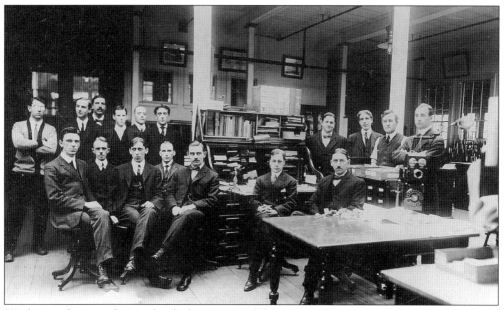

Workers gather together in the drafting room of the Draper Corporation.

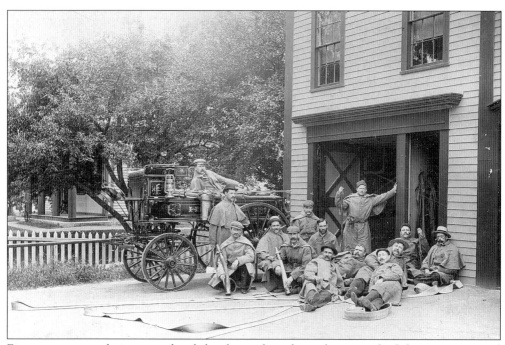

Fire insurance regulations mandated that large plants have their own firefighting systems and equipment. The Draper Company built two *c*. 1900. No. 1 Hose House at 24 Hopedale Street, seen here, had a tower for drying hoses.

This picture was taken at Heart's Desire (named by their son Tommy), the property of John and Margaret Byrne and family, who operated a dairy farm there from 1940 to 1949. From left to right are John, Regina, Ann Marie, and Mary Ruth. The horse was named Dick. The house and barn were on Hartford Avenue in South Hopedale, and much of the pastureland is now part of Hopedale Airport.

While most work in Hopedale revolved around the Draper Corporation, not all work was in the shop. The Draper Corporation purchased land in South Hopedale (the Byrne farm in the photograph above) and built the Hopedale Airport in 1950. The company's plane seen here is a Beechcraft Model D18S. Pilot H.O. Bessette stands by the aircraft in this picture taken in December 1950.

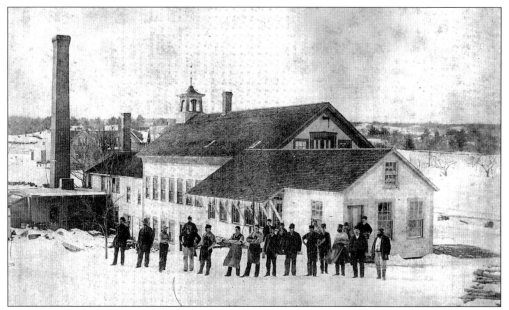

On September 13, 1947, the *Woonsocket Call* wrote about the Spindleville mill, noting, "The workmen [creating spindles] are craftsmen of the old school, and their contentment and pride in their work is probably unequaled in any other plant in New England. Here men have worked since they were mere youngsters, and today sons carry on jobs started by their fathers."

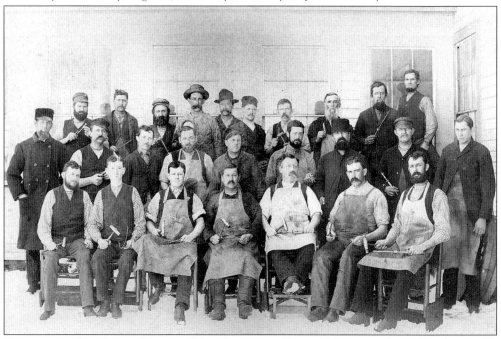

Longtime resident Reggie Sweet said the Westcott Mill started out as a cider mill and gristmill. "My father worked there before 1900 . . . when they made spindles for Draper's and also sold them to mills in Woonsocket and Connecticut. They had about 30 employees. I ran the boiler for heat and worked as a blacksmith at the power hammer. They had a water wheel that'd be used for power upstairs." Here, mill workers pose for a group picture.

This photograph reflects the prosperity evident in early Hopedale. Sturdy steeds, an elaborate carriage, and a driver adorned in tails and top hat appear to be awaiting a prosperous magnate and his family.

During the early years of the Industrial Revolution, the Draper Corporation flourished and became the largest producer of automatic cotton looms in the world. Joseph B. Bancroft rose to become president of the company. His elegant home was located at 48 Hopedale Street. This photograph shows stable men and horses in his driveway at the side of his house, with the Day house in the background.

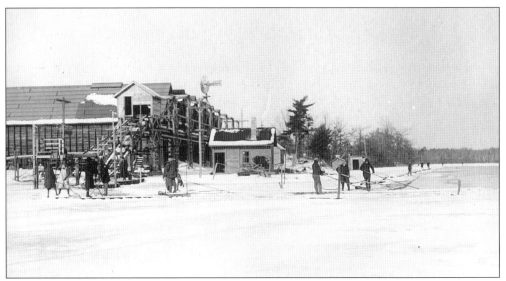

This photograph shows workers cutting the ice on Hopedale Pond. Note the immense size of the icehouse, as well as the windmill. A former employee recalled the windmill was used to pump water from the pond.

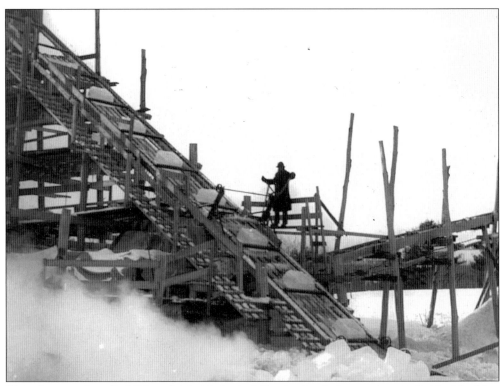

This photograph, called "Hopedale's Method of Getting Ice," shows a lone individual looking on while the conveyor brings blocks of ice into the icehouse. The structure was located north of the Lake Street duplexes.

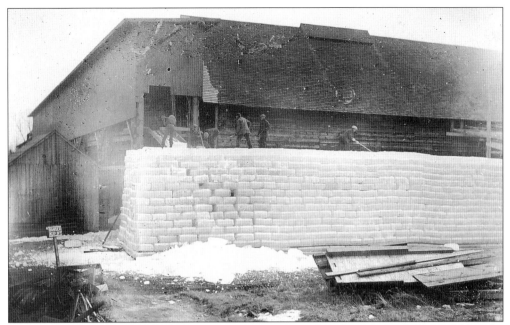

Cold winters kept the icehouse operation running smoothly throughout the year. Here, the blocks of ice stacked high show just how large an operation this was, especially when compared to the men on top. The ice would be buried under straw and hay to insulate it from the warm weather so people could use ice all summer long.

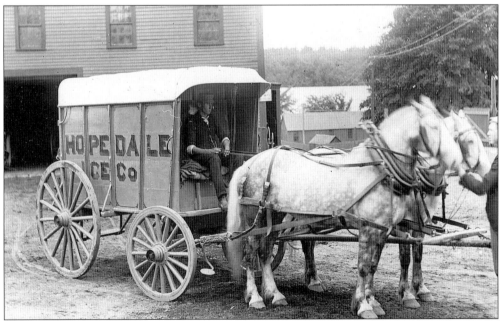

The iceman's job was hard work, but his face was welcomed by homeowners and children alike. Resident Dorothy Stanas recalled, "In summer, before we had electric refrigerators, we'd gather around the ice man as he delivered to homes in the neighborhood. Usually we would be given ice chips."

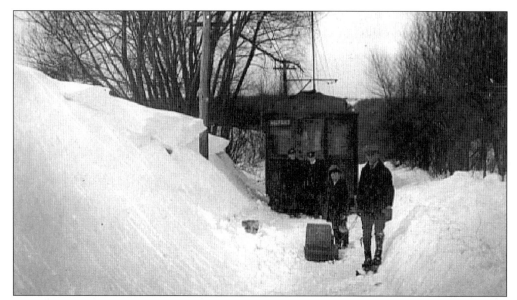

Transportation was and remains an important issue in Hopedale. Imogene Mascroft, in *Hopedale Reminiscences*, recalled, "The old stage coach and the tired horses that dragged it over the hill [to Milford] are no more. Peace to their ashes! In their stead, as if by magic, shining rails traverse the quiet streets, over which speed half hourly trolley cars, which in our day were not even dreamed of."

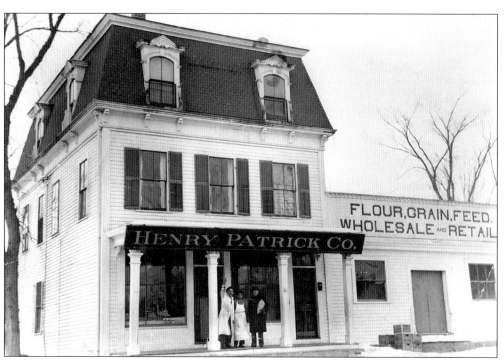

Henry Patrick ran a store known as Patrick's Corner Store, at the intersection of Hopedale Street and Route 16 where Stone's Furniture resides today. This intersection was long known as Patrick's Corner.

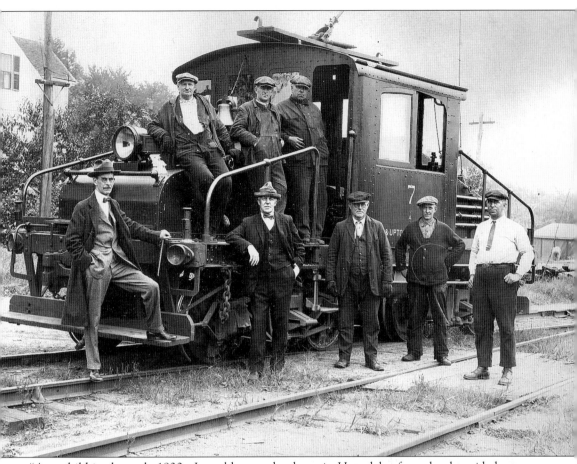

"As a child in the early 1930s, I would go to the depot in Hopedale after school to ride home with my dad, Harry Barker [top left], who was a brakeman on the train. If the engine was at the depot and had to make a trip to Milford, Dad would put me on the engine and away we'd go. At the crossings, Mendon Street, 140 and South Main Street, a crewmember would precede the engine, waving a light to alert traffic that the train was approaching. There were no barriers at that time and traffic was minimal. My thrill was when Mr. Snow [top middle], the engineer, would allow me to ring the loud bell on the engine as we neared the crossings," recalled Jean Barker Guglielmi.

For many years, the post office was located in the town hall. The people in this photograph are, from left to right Donald Arey, mail carrier; Albert Marso, clerk; Ralph Holt, mail carrier; Chick Rubeo, Draper employee; Red ?; William Larson, assistant postmaster; John Connolly, Draper employee; and Thomas Eckles, mail carrier.

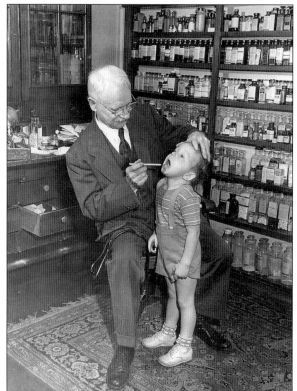

Dr. Kleber Campbell started his medical practice in 1900. Three years later, he and Mrs. Campbell moved to 82 Hopedale Street, where he treated his patients for the next 50 years. When a case of smallpox was discovered in Hopedale in 1902, the patient was isolated in a building on Route 140 near Upton. "People would drive miles out of their way just to avoid going past the pest house," Dr. Campbell said. (Photograph reprinted with permission of the *Worcester Telegram & Gazette*.)

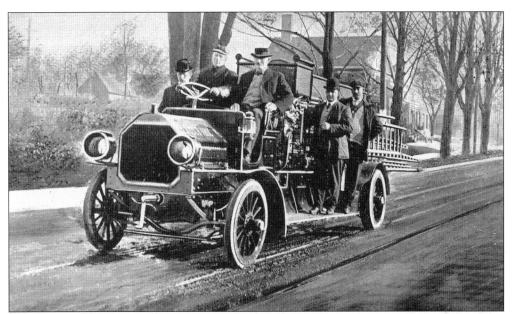

For many years, Sam Kellogg was one of the best-known people in Hopedale. In addition to being head of the highway department, police chief, and fire chief, the 1940 town report lists him as having been constable, tree warden, lockup keeper, forest warden, truant officer, and superintendent of gypsy and brown tail moth extermination. In this picture, he is seated to the right of the driver.

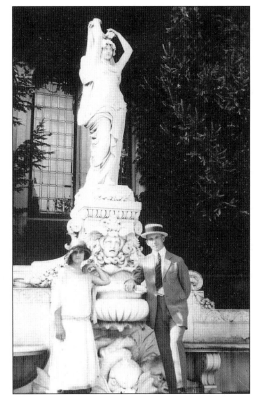

In the early 1920s, Thomas Malloy and Elizabeth Revette took a walk from Milford to Hopedale, where a friend took this picture of them standing in front of the Statue of Hope. He joined the Hopedale Police Department in 1929 and was chief from 1943 until his retirement in 1963.

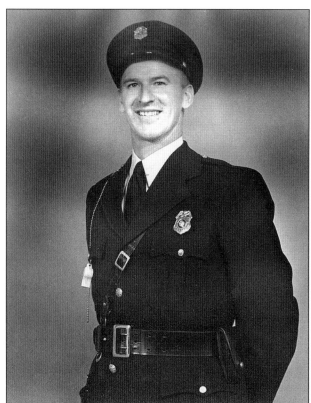

W. Chester "Chet" Sanborn was a prominent local figure in the middle decades of the 20th century. In addition to being a police officer, the 1960 town report lists his jobs as constable, tree warden, dog officer, superintendent of insect pest control, inspector of animals, inspector of slaughtering, and attendance officer. This devoted servant of Hopedale became chief of police in 1963 and retired in 1975.

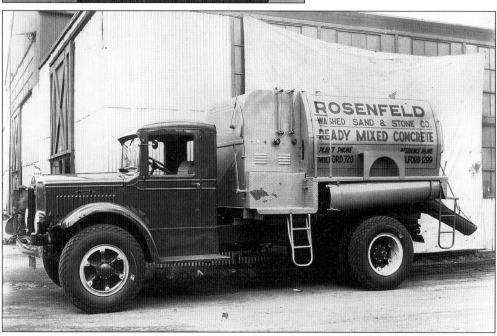

The Rosenfeld Washed Sand and Stone Company was established in Milford by Joseph Rosenfeld in the early 1920s and moved to its present location on Plain Street in Hopedale in 1929. The truck shown is a 1937 BX Mac with a five-yard Ransom mixer.

Nine

HOPEDALE IN AMERICA

Although small in geographic stature, Hopedale's reputation as a patriotic community is well deserved. Hopedale rose to prominence following the Civil War, when William F. Draper was named a general for his patriotic actions. An imposing statue of the general on horseback, created by famed Lincoln Monument sculptor Daniel Chester French, graces the nearby Draper Park in Milford, Massachusetts.

Politically, the Draper family also made its mark nationally and internationally, with Gen. William F. Draper serving as a congressman and later as ambassador to Italy. While there, his daughter Margaret married an Italian prince. She and her parents are buried in the Hopedale Village Cemetery. The general's younger brother, Eben S. Draper served as lieutenant governor of the Commonwealth of Massachusetts from 1906 to 1908 and then as governor from 1909 to 1911. During his tenure as governor, he was able to hobnob with Pres. William Taft both publicly and even in his Hopedale home.

Celebrating Memorial Day has long been a tradition in Hopedale, with solemn ceremonies taking place annually at the Hopedale Village and the South Hopedale cemeteries. Tombs of war heroes and veterans would be decorated—often quite elaborately—and schoolchildren would gather wildflowers and place them at the grave sites.

Since the town's incorporation in 1886, Hopedale has lost 26 men in wars, beginning with the Spanish-American War. Several streets in town are named after these heroes, including Hammond, Tillotson, and Steel Roads. The Griffin senior housing apartments are named after Richard Griffin, who perished in the Korean War.

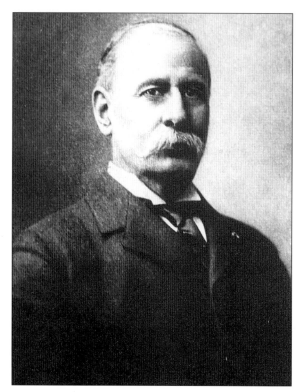

Gen. William F. Draper, son of George and Hannah Thwing Draper, served as a Union officer during the Civil War, was promoted to general, and retired in October 1864. In the 1890s, he went on to serve in Congress and was then appointed ambassador to Italy. His brothers removed him from his job as president of the Draper Company in 1906. He died in Washington, D.C., in 1910 and was buried in an elaborate mausoleum in the Hopedale Village Cemetery.

Eben Sumner Draper was born in Hopedale in 1858 and graduated from the Massachusetts Institute of Technology in 1878. He was chairman of the Massachusetts delegation to the Republican National Convention in 1896. He served as lieutenant governor from 1906 to 1908 and as governor from 1909 to 1911. Draper died of a stroke in South Carolina in 1914, and the final leg of the funeral train to Hopedale was via the Grafton and Upton Railroad.

"The times [1910], as I recall, were complacent and untroubled. . . . There were no wars or rumors of wars; women did not vote, smoke cigarettes or wear men's clothing. William Howard Taft was in the White House, and a native of Hopedale sat in the Governor's chair under the gilded dome of the State House in Boston," recalled Charles Merrill. This photograph shows Gov. Eben Draper (left) with President Taft on the porch at the governor's Hopedale estate.

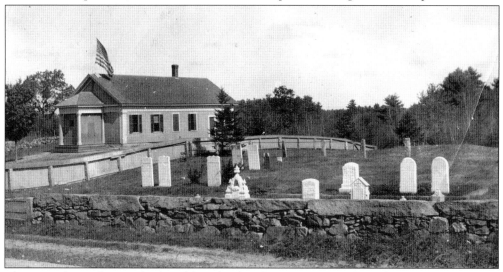

This view shows the South Hopedale School and Cemetery. Resident Elsie Jenks wrote, "[On Memorial Day] we were dismissed from [South Hopedale] school to gather wildflowers in the area. Returning to school, we made up bouquets. In the afternoon a Civil War veteran appeared with small flags. We had recitations, songs and a talk by the veteran. Then, led by the veteran and our teacher, we marched to the cemetery singing 'The Battle Hymn of the Republic' and decorated the graves."

Memorial Day parades have long been a proud tradition, culminating in services at the Hopedale Village and South Hopedale cemeteries. "It seems that every kid in town marched in the Memorial Day parade, each carrying a small flag. Afterwards, we went to the Legion Home for lemonade," recalled Dorothy Stanas, longtime resident.

Shown in the yard of Joseph Bancroft in the early 1900s, this patriotic couple was perhaps preparing to ride their tandem bicycle in a Fourth of July parade.

This honor roll was located beside town hall and named Hopedale men who served in World War I. Hopedale sons who died in the service of their country were Edward Burnham Jr., Paul Harris, Raymond Piper, Davis Gabry, Darrell Lindsey, John Raymond, and Walter Tillotson. Prior to this, Paul French became the first Hopedale resident to die for his country since Hopedale became a town, when he was killed in the Spanish-American War.

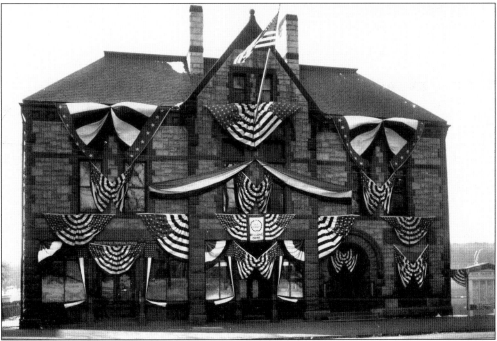

The patriotic spirit has been part of Hopedale's community fabric for decades. On special occasions, the town hall was completely decorated in red-white-and-blue bunting, while the American flag waved above. This photograph from December 20, 1919, shows the town's preparations to welcome home its heroes from World War I. (Photograph courtesy the American Textile History Museum, Lowell, Massachusetts.)

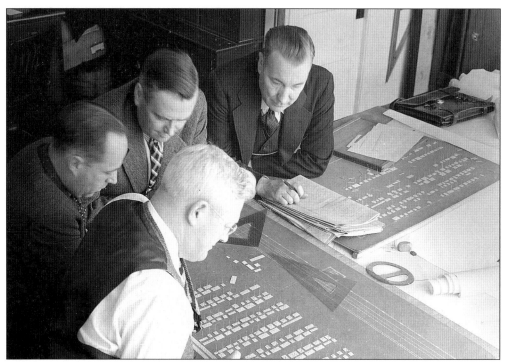

As the Draper Corporation changed its production to help with the war effort during World War II—producing internal grinders, 75mm howitzers, and magnetos—this group huddled together to solve a problem. Shown in front is John Hayes, who is identified as a planner. Behind him, from left to right, are Arthur "Chippie" Fitzgerald, assistant master mechanic; Frank Perry, assistant master mechanic, electrical; and Thomas MacNevin, master mechanic.

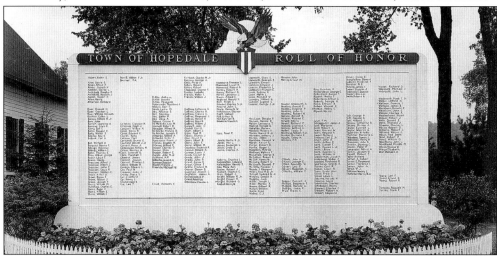

This honor roll near the former Legion Home on Hopedale Street paid tribute to the men who served in World War II. Fifteen of Hopedale's 3,000 residents died in the war, including William Baer, John Barr, Robinson Billings, Leverett Clark, Francis DeRoche, Francis Gaffney, Lowell Hammond, Harry Kimball, Richard Knight, Donald Midgeley, Joseph Miller, Henry Rumse, Fernando Spadoni, Francis Wallace, and Thomas Wilson. Later, Richard Griffin died in the Korean War, and Douglas D'Orsay and John Steel perished in Vietnam.

The World War II years were difficult times for most American families. In this poignant photograph, Olive Smith and her son James Holt of Prospect Street pause near their radio. Between them is a picture of another son, Ralph Holt, who was serving overseas in the army. The red-white-and-blue ribbon lovingly placed on the frame and the Hopedale Honor Roll seen above reflect their patriotic spirit.

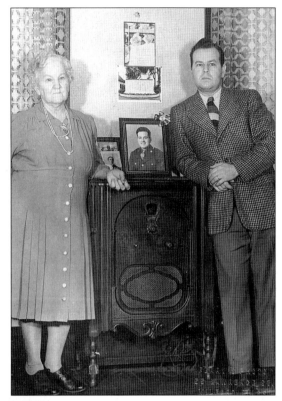

Army Pvt. Alfred "Freddie" Bresciani was wounded in action in Germany on December 14, 1944. He had previously been awarded the infantryman's combat medal for saving the life of a soldier in combat. He later received several other medals, including the Purple Heart and the Bronze Star. His brother Albert was in the navy during the war.

125

The Hammond brothers all served in World War II. Freeman (left) enlisted in July 1943 and became a master sergeant. Lowell (center), expecting a war, enlisted in the Army Air Corps and was killed at Port Moresby, New Guinea, on May 7, 1942, becoming Hopedale's first casualty of the war. Robert (right) went into the army in October 1942 and served in the Medical Corps in England.

One of the Hopedale men killed during World War II was Lt. Col. Robinson Billings, who died when the B-29 he was flying from China to Singapore was shot down on January 11, 1945. During the attack, he was badly wounded, and crew members pushed him out of the plane, hoping he would be able to parachute to safety. His body was found and buried somewhere near Singapore and was returned to the United States for burial at the Hopedale Village Cemetery in 1948.

Howard Felton (pictured here) grew up on Prospect Street. During World War II, he answered his country's call and served in the army. In Italy, shortly before the end of the war, he stepped on a land mine, resulting in the loss of one of his legs.

Lawrence "Larry" Heron entered the army on August 9, 1943. In France, on June 26, 1944, he sustained severe injuries that left him blind. His close friend Judge Francis Larkin noted that Heron "held the unique distinction of having the only post in the country of the Disabled American Veterans (DAV) named for him while still living." Resident Marge Horton recalled Heron's patriotic spirit and cited his involvement in veterans' programs and singing at many public functions.

Red-white-and-blue bunting, a banner, and flag show that the veterans of World War II were welcomed home to Hopedale with an elaborate banquet. At the head table are, from left to right, A.A. Lovejoy, A.A. Westcott, Rev. J.B. Hollis Teagarden, Thomas West, unidentified, William Ferguson, unidentified, William Summers (a well-known American League umpire from Upton who was a frequent local speaker), and "Fitter" Fitzgerald.

Richard Griffin was the only Hopedale resident killed in the Korean War. He had been an outstanding athlete at St. Mary's High School in Milford and enlisted in the U.S. Marines while in his sophomore year at St. Bonaventure College. The Griffin Apartments on Hopedale Street were named in his honor.